Brittlebush

Arizona through the Eyes of Its Elders

Memoirs, Stories, and Poems by Senior
Adults

Nadine L. Smith,
Editor

Elie Schultz
Associate Editor

Caroline Haines Burke
Illustrator

Scottsdale Community College
Scottsdale, Arizona
1993

The stories and poems appearing in this collection were submitted through the Senior Adult Writing Project, a program whose purpose is to promote writing in the upward years as a self-validating activity, one that enables seniors to share with a younger generation their historical perspective, rich experience, and creative talents. The project is sponsored by Scottsdale Community College and the Desert Foundation. All proceeds from this book go toward the continuation of the project.

Library of Congress Cataloging-in-Publication Data

Brittlebush: Arizona through the eyes of its elders: memoirs, stories and poems by senior adults / Nadine L. Smith, editor; Elie Schultz, associate editor; Caroline Haines Burke, illustrator.

 P. cm

 ISBN 0-9617772-3-0

 1. Aged, Writings of the, American—Arizona—Scottsdale. 2. American literature—Arizona—Scottsdale. 3. Arizona—Literary collections.

I. Smith, Nadine L. II. Schultz, Elie.

PS508.A44B75 1993

810.8'09285—dc20 93-34881 CIP

FOREWORD

When the brittlebush (encelia farinosa) is young, its leaves are grayish green, turning nearly white as the plant matures. Although its leaves are gray and brittle, it is one of the most conspicuous plants in the desert southwest, setting whole hillsides aglow with the brilliance of its abundant yellow flowers. The writers whose works appear in this collection of poems, stories, and reminiscences are not unlike the brittlebush as they continue to produce bright patches of beauty in late maturity.

Brittlebush is the fourth anthology to be published by the Senior Adult Writing Project at Scottsdale Community College, but the first to have "Arizona" as its theme. The historical perspective is included in many of the works, but we did not want to limit the scope of the book to reminiscences of an earlier Arizona. Instead, we hoped to offer a wider glimpse of Arizona past and present through the eyes of some of its elders. Some of the stories are true, some are fiction; but the fiction pieces are true to the Arizona theme in character and setting.

In prose and in poetry these elders capture the spirit of Arizona with word pictures of canyon, desert, and wildlife; of native American myth and artifact; of cowboys, miners, and other old-timers; and in tales of Arizona's small towns of an earlier day. The stories acquaint us with Phoenix and the Salt River Valley as it was experienced by a schoolgirl in 1918, by moviegoers in the thirties and forties, and by a black couple who moved to all-white Sun City a few years ago.

We are indebted to the Desert Foundation for the initial grant which made this series possible. We are also grateful to the faculty and administrators at Scottsdale Community College who continue to encourage and support the Senior Adult Writing Project. We are especially grateful to those who served on the advisory committee for the project: Judy Bloyer, Tony Clark, Fara Darland, Eric Loring, Eugene Schmidt, Cheryal Nimsky-Taylor, and Julie Wambach. Special thanks and appreciation also to Elie Schultz for her editing and formatting, to Caroline Haines Burke for her illustrations, to Mary Spencer and Bella Simons for their limitless help with the manuscripts, and to all those senior adults who submitted their stories and poems.

Nadine L. Smith, Coordinator
Senior Adult Writing Project
Scottsdale Community College

The Senior Adult Program
of
Scottsdale Community College

Presents Its Fourth
Collection of Prose and Poetry

MARICOPA
COMMUNITY
COLLEGES

CONTENTS

Phoenix and the Salt River Valley
Then and Now:

Other Places, Other Times:

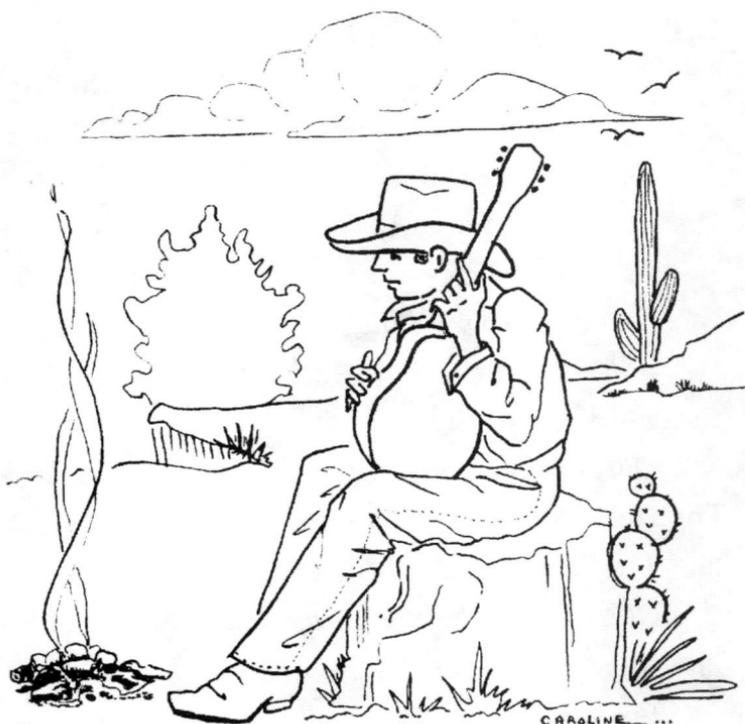

Cowboys Miners and
Other Old-timers

The Last Cowboy

Nell Brown

I remember vividly a certain spring evening when I was pitching horseshoes with three of my brothers and one of them shouted, "Hey! Look! The old cowboy's campin' tonight!"

A half mile away, the telltale smoke from a campfire curled up into the sky. Without further discussion we were off, trotting barefoot along the narrow dusty road that led from our homestead to the outside world.

A brief shower had barely kissed the parched grass and sunburned creosote bushes that flourished on all sides, releasing a sweet fragrance found nowhere else on earth. Long figures of sunlight and shadows reached across the valley from the sun that was sinking behind the mountains four miles to the west. Low clouds changed colors rapidly from pink to orange to red and then to the soft gray of approaching night.

My brothers and I trotted silently, unhurriedly, knowing from other visits that we would be greeted graciously—as guests. Among the other desert trees were low-growing salt brush that provided flimsy shelter for rabbits who waited quietly for us to pass before bounding away across the desert. Baby quail hid beneath low branches while their parents bravely flaunted their presence to protect their little family.

The old cowboy, who rode over hundreds of acres of unfenced land searching for lost calves and tending to the varied needs of range cattle, carried his simple necessities on his horse with him: A canvas-wrapped bedroll was tied securely behind his saddle, ready to spread out on the desert floor when sunset overtook him. Two feed sacks hung on his saddle horn. One carried a skillet, a blackened coffee pot, dried meat, canned cream, and such simple rations as he used while riding the range; the second held his beautiful walnut-colored guitar, carefully packed in its own felt-lined case.

We could see the cowboy clearly now, sitting on a fallen mesquite log, drinking coffee from his tin cup. When he saw us approaching, he lifted his wide-brimmed hat in a welcoming salute that was familiar to us, for we had already spent many evenings around his campfires. We loved listening to the haunting ballads he had memorized on trail rides shared with other cowboys.

It was almost dark when we settled down around his campfire, cross-legged on the sandy bed of a dry wash that, long before our time, had known the soft shuffle of the moccasined feet of Indians. Only pale lamplight was visible in the scattered homes where our neighbors lived for, in 1929, electric power had not yet come to our valley.

We didn't notice those things much, however, because the beautiful guitar was being lifted from its case. As the cowboy tuned his instrument, he began instructing us on how it was done. This night, too, was the first time he allowed each of us to hold his guitar in its proper position, and learn to depress certain strings with the fingers of the left hand while strumming with the fingers of the right hand to make a pleasing blend of musical sounds. What a magical accomplishment I felt when I met with success and began to dream of someday owning my own guitar, of making music like the old cowboy did. I started memorizing the words to some of the ballads he loved—stories in song about the lonely and sometimes beautiful way of life lived with the freedom of the wind that found no barriers when it whispered across the desert.

While we sat in that ring entranced with his singing and an occasional melody played on the strings of his guitar, the moon slowly rose above the low hills in the Harquahala Mountain range that enclosed a portion of our valley. Between

songs, he shared fond memories the songs brought back to him, and we vicariously relived those special moments in his life.

We remained for an hour or more around the dying embers of his campfire. The moon rose higher, casting pale, ghostly shadows beneath mesquite trees that grew along the little washes. It was almost as light as day when we began our trek back home, again trotting one behind the other and calling, "Goodnight! Goodnight, and thank you!"

After cattle roundup in the fall, the old cowboy returned to his home in Prescott to be with his family over the holidays. So it was spring when he came riding his horse up to our homestead and tethered it to a hitching post. On the saddle horn this time hung two guitars and one of them was a gift for us! What a gracious gift from a man whose mind and heart fathomed our need, growing up as we were on a lonely homestead in the middle of the wide desert rangeland during the Great Depression. A hand-cranked victrola that spun tinny music from heavy records and a static-filled, battery-operated radio were the only other musical or verbal communication we had with the outside world. Our friend shared the noon meal with us around the kitchen table and, afterwards, taught us how to depress the guitar strings to make chords to accompany our own simple songs.

Each of us learned to chord guitars well enough to entertain in our small town. Eventually I became part of a local group of music-makers who practiced in one another's homes. We provided music for dances at schoolhouses and garages in surrounding small towns. It was not a moneymaking venture. We did it for entertainment. A small container was placed where people could drop donations for special requests or to show appreciation. Dances began at 8 in the evening and lasted until midnight. Sometimes we each made $4 for the evening.

I left the area when I was seventeen to work for room and board and attend high school in Wickenburg, and so lost touch with the old cowboy whose visits had become infrequent as he grew older and the cattle business began to falter. When he died from pneumonia a few years later, I owned a guitar. But I remember distinctly the empty space his departure left in my life for a time.

Shortly after his death, as a farewell, I carried my guitar out of town one evening and sitting alone on a little hill, watched the beautiful colors of a sunset and sang some of the ballads he taught me, and one special song he loved.

He was the last cowboy I knew. Even today, when I pick up my guitar at infrequent times to strum a tune, all I need do is close my eyes and concentrate on the scrapbook of my mind—that long ago evening around the campfire when I

first held his guitar, and the old cowboy comes riding out of that past.

In my mind's eye, he still sits very straight in his saddle, creaking leather chaps protecting him from the thorny branches of trees as he trails cattle across rangelands that no longer exist. A wide-brimmed hat is tipped slightly back on his head, and on his suntanned face is his ready smile, as real to me today as it was when I was twelve.

✪

Hassayampa Joe

(Fiction)

Don West

"C'mon, Sam. Get your butt up here. It's chow time." The dog moved over stiffly and sniffed at his plate.

"Sam, you're getting fussy in your old age. Time was when you'd just snap that stuff up. Well, I guess I don't blame you none. I'm slowin' down myself. 'Bout time I pulled the pin. Maybe go down to Mexico and live there. It's cheap if you don't mind frijoles and tortillas. Which I don't. Lots of places to pan gold and nobody bothers you."

Joe talked to Sam a lot. He had to. There wasn't anyone else out there and he didn't fancy talking to himself. "I guess it's OK talkin' to yourself, but when you answer back, that's when you got a problem. Y'know, they joke about me, Sam, spendin' all this time in the Hassayampa Valley.

I been prospectin' along this river for ten years now. Sure, there ain't much water as a rule, but when there is, I can get my pan out and get a few colors sometimes. Sam, I just know it's here. Sure, they found some real fine gold along here to the north, but I think that washed down from Henry Wickenberg's Vulture Mine. When the gold's that fine, means it's traveled a long ways and don't amount to much. Henry shut 'er down in '72 and I never seen him since. I did get some good gold north of here in Placenta Gulch a couple years back, but it petered out on me.

"That's where I met old Jake Walz. He got some pretty good nuggets out o' that place. We was sittin' around the campfire one night when Jake said, ' Joe, I'll tell you a secret if you swear never to give it away.' What'd I have to lose, Sam? Somethin' to pass the time. So, I said, 'O.K., Jake. I won't tell.'

" 'Well,' says Jake, 'I got this claim up in the Superstitions out of Apache Junction. There ain't nothin' there, so I figure I'll take these nuggets over there and make it look like I found them on my claim. Then I'll go into town and raise hell and tell them this phony story. There'll be all kinds of dumbbells goin' around lookin' for the gold that ain't there. I'll have some fun with it, anyway.'

" 'Jake,' I says, 'I think you've been out in the sun too long. It's fried your brain.' I never saw old Jake again. He died in Apache Junction, but from

what I hear a lot of folks went lookin' for his gold. They called it the Lost Dutchman's Mine. I guess I'm the only one what knows the real story and I never told no one. Let 'em have their fun. That's what Jake wanted.

"Sam, I just feel it in my bones. There's a real pocket of high grade around here. And I'm gonna strike it rich."

Sam looked up from his dish like he'd heard this story before.

"Well, Sam. We'll bed down here tonight and head downstream in the morning to Blue Tank Wash. After that rain yesterday there'll be water in the stream bed and we'll do some pannin'. Some of them townsfolk and dudes comes out here lookin' for gold, but they don't know what they're doin'. The big nuggets is down in the riverbed stuck behind the rocks where the current dropped 'em. Or down to bedrock. You gotta know where to look."

The morning sun rose over the White Tank Mountains and its glow crept across the valley, casting long shadows over the landscape. The shadows shortened as the sun rose higher.

"This here desert's beautiful, Sam. It never looks the same twice. I never gets tired of it. Well, let's get goin' before the sun gets too high. I can't take the heat no more like I used to. Keep an eye out for them rattlers. The rain drives 'em from

their holes and they'll be along the banks 'til they can get back in."

Joe and Sam moved on downstream and there, around a bend under some palo verdes, was a backwash from yesterday's rain. Joe dropped his gear and got out his gold pan.

"Let's try it here, Sam. Looks like as good a place as any."

Joe squatted down on his haunches, dipped his pan in the water, dug down into the streambed and scooped in a couple of handfuls of gravel.

"This is where you gotta look, Sam," Joe lectured. "On the inside bend of the stream. The current slows down here and loses its carryin' power and drops the gold out. Those damn fools that don't know that will never get nothin'."

He sloshed the sand around in his pan with the skill of a longtime panner. He kept the lip of the pan just below the water level, moving it in a circular motion, bumping the edge with his palm to drive the gold down to the bottom of the pan, and letting the waste material drift out into the stream. He kept this up for a while, picking out the larger stones by hand until he had a small amount of material left in the bottom of the pan.

"Nothin' here, Sam," Joe said, raising the pan up close. "Just black sand, a little fool's gold, and some garnets. I guess we'll go on a while more. And if nothin' shows up, we'll head back in to Wickenberg. It's about thirty miles and we can

make it by tomorrow night. Get us a good meal and some cold beer and rest up a while."

Joe dumped the sand back into the water, moved downstream a bit, and started over again. He kept this up for about an hour, talking to Sam as he worked. The sun rose higher and Joe thought of knocking off and getting into the shade for a while.

"One more pan, Sam. Just one more."

Joe dipped his pan in the water and commenced to swirl the sand about when he gave a shout that nearly cracked his throat.

"Sam! Sam!" he yelled. "I got it! I got it!" He jumped up, holding a nugget the size of a pigeon's egg in his hand. He started to dance a jig in the sand, but his foot caught on some driftwood and he fell backwards into the brush.

He didn't hear the rattle, if there was one. And knew only the sharp pain in his left thigh. He swung the pan downward, and with one blow crushed the snake's head on a rock as it struck toward him again.

"God, Sam. He got me good! God. Look at the size of him. Must be four feet long. Sam, I'm in real trouble. I got a snakebite kit, but I won't get the tourniquet around my leg. The bite's too high up."

The pain was getting worse and Joe pulled himself under a palo verde tree and propped

himself against the trunk. He looked at the nugget clutched in his palm.

"Fate's dealt me a rotten hand, Sam. After all these years, I find the lode and lose it at the same time."

Sam was whimpering. He knew something was wrong. He'd seen the snake and was trembling with fear. He'd been bit by a sidewinder when he was a pup and almost died. Joe'd forced a piece of hose down his throat so he could breathe. He'd lost part of his muzzle and carried an ugly scar as a reminder.

"Take it easy, Sam. It's OK. All I can do is take it like a man. I guess it could've been worse. Like croakin' in a flophouse in some boony mining town. I guess I oughta be grateful I'm out here on the desert. This is my home. Not many folks could be that lucky. He reached over to his packsack and took out a small, dog-eared Bible.

"This is gonna take a while, Sam. I might last another day, maybe. You know, Sam. I never hurt one of those critters, ever. 'Live, and let live,' I always said. I guess I scared him and he was just defendin' hisself. I'm sorry I killed 'im."

The pain was bad now and his vision was blurring. He opened his Bible. "Always like John best, Sam." The desert sun went down over the Big Horn Mountains and rose and set again. Joe raised his dimming eyes to the distant hills.

"Let not your heart be troubled," he quoted. "Believe in God and believe in me. In my Father's

house are many mansions; if it were not so, I would have told you; I go to prepare a place for you."

Joe's head slumped to his chest. The Bible slipped from his fingers into the sand.

They found Joe the next summer. The sheriff identified him from some papers in his pack. There wasn't much left of old Joe. Just dusty, dry clothing and cracked boots, some mummified skin, bones picked clean by varmints and bleached by the desert sun. Alongside him was Sam's little skeleton. He'd stayed by his master and starved.

As they went to move him, the sheriff looked down and there in the bones of Joe's hand was a large, gold nugget.

"I guess he must have got that out of his pack for old memory's sake before he died," the Sheriff said. "I guess the heat got him. The crazy old coot's been out here all these years wastin' his time. Anybody knows there's no gold this far south on the Hassayampa."

✪

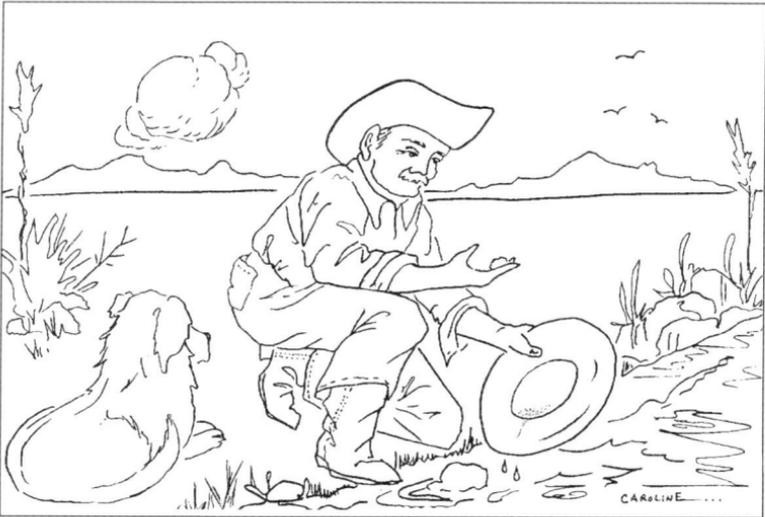
CAROLINE ...

Burt Loper's Boat

Bob Finkbine

Then a young man, he forged
the metal tie-off ring
and fitted, hammered, shaped,
sawed, nailed, glued, sanded, planed
and painted the boat by hand.

Now its peeling remnants seem to grow
out of the soil of its resting place
where wind and rain of passing seasons
flay at frayed plywood
and rust nail heads.

In 1949, nearly eighty,
he capsized and drowned,
his boat carried another fifteen miles
before washing high up on the right
bank below Buckfarm Canyon; left
there, it makes a frail moment

to a man who loved the river
as he did his children
and who grew strong, then old
riding its bucking, hackbacked tide.

He was at home
in the colossal indifference
of the canyon, in its long-snaked,
striated story of the planet.

The splintered wood
honors not accumulation
but homage
to sandstone walls,
seeps, trickling springs
and the way
cactus claws at intruders
who will not pass this way again.

'Tain't No Matter

Helen Lawler

In Bagdad in 1910, no one knew where William Rudkins came from or how he happened to end up in the isolated Eureka mining district with its jagged mountains and treacherous canyons. But they remember him, and when oldtimers get together, someone inevitably spins a "taint no matter" tale about Rud.

Rud was typical of most prospectors in the Arizona Territory. Their pasts were as faded as their Levi's. Folks liked the old miner's happy-go-lucky ways and his kindness. Under his dirt-starched flannel longjohns he wore year-round, beat a generous heart. When he laughed or smiled, accordion pleats of wrinkles traveled across his leathery face. He loved to whistle except when he had a chaw of tobacco in his mouth. Then he hummed. He could tramp miles over sharp rocks without tiring. And his muscles were as solid as tungsten. Some said Rud had to be in his seventies. At least.

He lived off beans and dreams of striking it rich. "Then I'll move to Prescott," he'd crackle.

Rud had eventually made his home under a huge cottonwood and everything he owned was scattered around the tree or nearby. Higginbotham, his bridled burro, was tethered to a sturdy catclaw bush loaded with cream-colored blossoms. Once a friend remarked, "Higginbotham. That's a funny name."

"Well, I'll tell you," Rud said. "The feller that sold me the temperamental critter was Gus Higginbotham. You remember the sour cuss? Recall he seldom smiled and, when he did, his lips folded clean up to his nose. And his buckteeth came at'cha." Rud guffawed. The man said, "Hey, you're right. There is a resemblance."

"Most of the time I call him 'Higgie', 'cept when I'm fed up with his sneaky tricks. Take last week when he tried to brush me off. The scoundrel dashed under some low branches on a mesquite tree. Gawd. You know how thorny they are. You could have heard my 'damn you, Higginbotham' yelps clean over to Scott's Basin. Well, 'tain't no matter, 'cause most of the time Higgie and me get along jest fine. Couldn't do without him."

Setting up camp was simple. Rud looked for a site handy to water and his Southern Belle claim, unloaded his meager belongings and put up the patched tent he seldom slept in. He tied a cord to his blotched mirror, hung it on a tree limb, and adjusted it to his six-foot height. Although his

clothes were disreputable, he liked to be clean-shaven and kept his bushy, sandy-colored eyebrows neatly trimmed. Eight months out of the year, Rud lived outdoors. The high desert air invigorated him with its scent of sage and pinion. At sundown he loved to watch the mauve shadows creep among the ocotillos and ancient saguaros on the slopes of Blue Mountain, but when frost painted the roadside weeds white, he gathered up his things.

He sought work and shelter at the Hillside Mine on Burro Creek. Jack Lawler, the owner, always hired him, providing a shack. He could buy groceries at the Company Store, cook his own meals, or eat in the boarding house. He chose the latter. The grub was good and he could gab or play cards after supper and sometimes someone would crank up the graphophone. Rud enjoyed his stays at the mine. He made good wages, saved his money for grubstakes, and waited for spring.

Then he was back at his old sites, but could hitch rides on the freight wagons to the Hillside Station eight miles away. He could get just about anything there from a haircut to blasting powder at Darnall's store, and if he needed to stay overnight he could board Higgie, get a bed for himself and breakfast for $3.

Now, as cottonwood leaves quivered in a gentle breeze, Rud sipped his coffee and watched an April morning come alive with bird chatter.

A long purple lizard clung to a smooth boulder. Above Bozarth Mesa, a red-tailed hawk soared in circles. In the east, the Bradshaw Mountains were bathed in a soft amber glow.

He decided to hunt for fresh meat. This included anything that flew, ran, or swam. Mostly squirrels and cottontail rabbits. Plentiful doves and quail were too mild for his taste. His favorite bird was blackbird, but when they were scarce, he substituted roadrunners. He liked their flavor, but admitted, "They're pretty damn stringy."

Pete Robles, living several canyons away, knew Rud wasn't joshing with his stories about cooking these unusual dishes. He'd watched Rud "dress" the birds for his famous bird mulligan that were plucked hit or miss. Invariably, down and feathers floated to the top of his concoction.

Once Pete quizzed, "Must be a job picking out the buckshot."

" 'Tain't no matter. A little buckshot never hurt nobody. And it don't affect the flavor none."

No one ever asked for his recipe. Nor did anyone, knowing of his failing eyesight and his carelessness with firearms, invite him to hunt on their land. Take the time Rud moseyed over to Alex Lucy's place carrying a Winchester 30-30. Alex was delighted to have company and the men hunkered down in the shade of an alligator juniper. The two talked about the three Mexican

whores who had recently come through, lugging blankets.

"Same ones as last year?" Rud asked.

"Yep. "

"Seen Taylor lately?"

"Nope"

"No? Well he's down in the back again. Claims it's his rheumatism." Both broke out in wicked laughs.

Alex noticed Rud focusing on something in the distance.

"What are you looking at?"

Rud had spotted a plump squirrel darting in and out of a pile of rocks near Alex's cabin. "Mind if I shoot the varmit? Ain't no pet or nothing?"

"Okay with me," Alex said, figuring Rud couldn't hit the broadside of Lawler Peak if he tried. "If you blast that squirrel with your 30-30, all you'll have is fun and lead."

Rud chuckled and reached for his rifle. Alex covered his ears and moved away. Rud fired. After gulping dust, they walked toward the target. Sure enough. All they found was bits of splattered entrails. "See, I told you," Alex groaned.

Rud grinned, " 'Tain't no matter."

Alex talked about his new aluminum cookware from Sears Roebuck. "Say, how about staying for

supper? You can't leave. Not until you've seen my cookware."

"Okay. A quick look. Then I'll scoot."

Pushing open the cabin door they were engulfed by billows of black smoke and the sound of liquid dancing on a hot surface.

"Smells like burnt gravy," Rud observed.

Alex, coughing, ran to his woodburning range as Rud inched back toward the exit. Alex's brand new teakettle had a bullet hole smackdab through its shiny middle and his six-quart soup pot had also been in Rud's line of fire. Beef broth oozed from the punctures.

Alex seethed. "You rubber-brained fool. You've ruined my aluminum utensils. Don't you ever step foot on my property with a gun again."

Rud made a hasty retreat. "I'll pay for the kettles," he called back. If Rud said, " 'Taint no matter," it was under his breath.

Summer had melted into autumn, thunderstorms had cooled and greened the high desert, and the air was filled with white butterflies. The old miner pulled his worn cardigan around his broad shoulders.

He heard the cracking of bushes and the crunching of gravel. His hearing was better than his eyesight these days. A familiar, buoyant voice called, "Howdy neighbor."

It was Big Mike Lawler. "Didn't expect to find you here. Heard you had packed out."

"Naw. Changed my mind. Weather's been good. Wanta get another week's work in on the Southern Belle."

"How'd it go at the Belle?"

"Slow. Ran into hard rock. Say, Mike, I was fixin' to dish myself some frijoles. How about joinin' me?" Big Mike loved Rud, but breaking bread was something else. He'd made too many excuses in the past and didn't want to hurt Rud's feeling. At least he wasn't offering bird mulligan as he had last time.

"Be pleased," Mike said.

A slow smile crept across Rud's face. "It's a real pleasure having someone to share grub with besides a jackass."

"Anything, I can do?"

"Naw, Mike, jest take it easy."

Rud went to a Hercules dynamite box that served as his cupboard and took out bent forks, chipped granite cups, and plates fissured with grease and rust. He laid them on a wooden crate. He walked to his grate, took a dented tin cup blackened by dried bean liquor, and ladled up chocolate-colored frijoles. He handed the plate to his guest.

Rud was fixing to dish up a mess for himself when he suddenly stopped. Mike watched. Rud

stammered, "Well, I'll be damned." He took another look into the deep pot, then gingerly reached into the kettle with his grimy hand.

"Dammit, that's hot!" he muttered, pulling out a fat lizard by its tail. He held the creature over the simmering beans so the juice could dribble back into the pot. And without a smidgen of embarrassment, nonchalantly tossed the inert reptile over his shoulder. The limp lizard landed on a clump of brittlebush.

Rud snapped his suspenders and clucked, " 'Tain't no matter."

His mouth watered as he dived into the legumes. He didn't notice that Big Mike had turned green as he stared at the brown frijoles before him.

<p align="center">***</p>

EPILOGUE: William Rudkins sold the Southern Belle. He moved to the County Farm two miles from Prescott. He wore a three-piece suit every day, and walked to town, using his cane. He spent afternoons in the back room of Mathis & Lynch's jewelry store in the Lawler Building on Cortez Street. He loved to reminiscence about his prospecting in Western Yavapai County. Rudkins died at the home of a niece in Ohio.

Man With a Dream

John Anderson

G-O-L-D. Whenever I hear anyone say this word with a long drawn-out expression of awe, I think of Lee Turner. He worked for my father on The Crescent, our Arizona cattle ranch, whenever he wanted money to finance his never-ending search for the precious yellow metal.

"Trouble is," Dad often said, "Lee Turner doesn't want to be a cowboy. He wants to be a prospector. If he can't get a grubstake, he'll hire on as a hand, work for a while, draw his pay, and all of a sudden take off with a faraway look in his eyes. Gold fever has ahold of him again!"

I was a chunky, 12-year-old when Lee rode horseback to the corral where I was trying to bulldog a calf. Boots dug into the packed earth, I tugged and struggled to wrestle the steer to the ground where I could tie him down.

"John, let me show you how to bulldog a calf."

I let go my grip and looked at the man climbing over the corral fence. Medium height and of slight build, he stepped to the ground, and moved awkwardly toward the little crowding pen, spurs jingling. Tufts of coarse black hair stuck out through holes in the crown of his felt hat. Lee bragged about being part Cherokee and, with morning sunlight bouncing from the burnished high cheekbones, he looked Indian.

Without a word of explanation, Lee grabbed the panting calf. Showing no signs of effort, the cowboy flipped the animal and laid him on his side fully four feet away.

"How did you do that?" I asked.

He showed me the hand holds—left hand on an ear, right hand around the nose. I did as instructed, but lost my balance and began the wrestling again. (It would be years before I learned timing and the quick, flipping motion the maneuver required.)

The summer after I graduated from Phoenix Union High School, I was working at the ranch when Lee wandered into the shop and asked, "Suppose it would be all right if I used your dad's forge?"

"Sure," I agreed, thinking he wanted to set a horseshoe.

When Dad replenished the empty coalbin, I told him about Lee's asking to use the forge.

Dad wondered how anybody could use one hundred pounds of coal in such a short time. He found out a week later when we found Lee bending over a coal fire in the shop, sending sparks flying as he cranked the bellows.

"What in hell are you doing?" Dad asked.

"This is a secret mix of metals. I'm fusin' 'em to make g-o-l-d." He kept watching, hoping to see the molten metal change into gold nuggets.

Dad walked away shaking his head. But he laughed that night telling Mother the story.

She said, "That man tells so many wild stories, people wonder if he is crazy." She said the first time she met Lee, he fixed her with a piercing look and told her he made a trip to Washington D.C. to confer with President Coolidge on Indian affairs. He even boasted of a newspaper picture of himself and Mrs. Coolidge on the White House steps. He never produced the picture.

To anyone who would listen, he repeated many tall tales. One of his favorites was insisting that Harold Bell Wright stole the story of his life for the novelist's book, *The Mine With The Iron Door.*

For many years, Dad was uncritical of Lee's ranting and eccentricities, saying the man was simply a dreamer, until the cowboy went too far.

One day late in October before the end of World War II, the sheriff's car drove into our Crescent Ranch and a deputy informed Dad that he was under arrest. Lee had told the sheriff's office that

he had several million dollars worth of Spanish silver bullion and feared for his life. He reported that Dad and some of his cowboys planned to rob him and his friends of their treasure as they brought it out of the mountains on pack mules.

Of course there was no silver, so there was no arrest. It was then that Dad joined those who listened to Lee's wild tales, observed his bizarre behavior, and called him crazy.

Dad reported him to the authorities.

Lee grew more wild-eyed and gaunt. Ribs protruding, the movement of his beating heart showed beneath his shirt as he insisted, "I *will* find gold. And if I don't find it, I will *make* it. Gold. G-O-L-D!"

Lee Turner was never committed. He filed a countersuit on my Dad, claiming defamation of character. No action was taken. The suit never came up for a hearing. The court dropped the charge at my father's death in 1939.

I don't know what happened to the old dreamer, because he left our country without saying where he was going. In my mind I picture him entering the "pearly gates," marching down golden streets and asking St. Peter, "Did you make all this G-O-L-D?"

❖

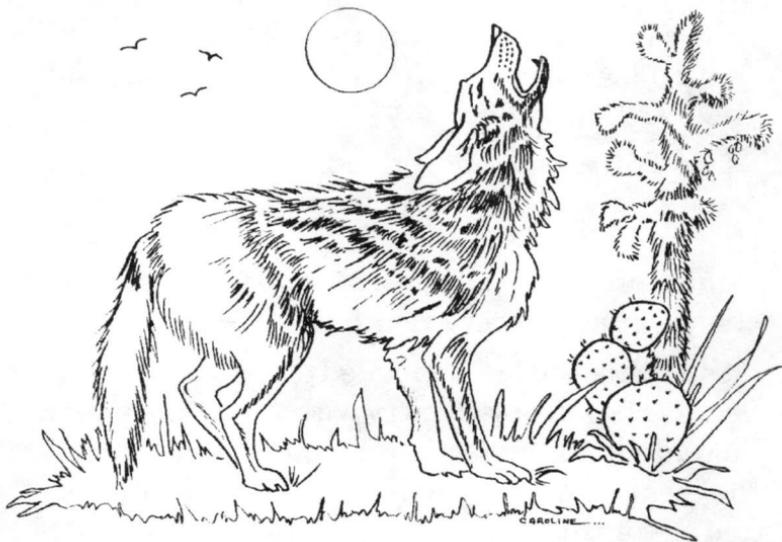

Cactus, Canyon
and Critter

Hunger

Jules Klagge

Hidden in the vastness of the canyons,
nestled among cactus, palo verde,
greasewood, ironwood and cholla,
 lies a den protecting life.

Mother coyote, brown of fur,
muzzle flecked with foam,
limps across the mica-sparkled granite,
picks her way among the diamond sharpness,
 guardedly shuns broken schist and thorn.

Seeking blood or bone,
living fur or feather.
Ribs protruding, nipples dry and cracked,
she pauses on the crest of a small rise,
 tests the wind for tell-tale scent of game.

Mocking scent of greasewood
is her only answer.
She lifts her muzzle to unyielding sky,
with quavering tone of anxious pleading
 moans her protest to impassive hills.

Deep in the gloom of hidden canyon den,
products of her body softly whimper.

Arizona Desert

Bea Bradshaw

"You shouldn't decide to settle anywhere until you have seen Arizona. Come and visit us this winter in Apache Junction." This was the invitation from our dear, longtime friends in St. Paul, Minnesota.

So the fall of 1969, the second year of our retirement, we hitched up our Holiday Rambler and headed for the Southwest. We arrived at a trailer park in Mesa on the first of December and called our friends who lived near King's Ranch at the foot of Superstition Mountain.

Their little adobe brick home was nestled in several acres of wild desert, surrounded by palo verde and ironwood trees, saguaro, cholla, staghorn, barrel and prickly pear cacti. Hovering over it all was the majestic mountain.

We sat in lounge chairs on the east patio of our friends' house, absorbing the sun's warmth and looking over the wide expanse of unfamiliar terrain. From under a bush appeared a nose,

then long ears. A rabbit hopped into sight, followed by another, then another. They scampered over rocks and pebbles and under cholla. They nibbled at a prickly pear, then disappeared.

"Look," said our hostess. "Over there is a gambel quail." We looked where she pointed and saw a plump, rust-gray bird with white stripes and a black, comma-shaped topknot waving over its brown helmeted head. It ventured a few inches from the protection of a prickly pear. Then we saw another, then another, then still more. Soon it seemed they were scattered all over the ground, their topknots bowing as they bobbed up and down eating the seeds our hosts scattered for them.

Hummingbirds flitted to the bird feeder hanging from a palo verde tree branch, sipped the nectar, then flew away. Birds of many kinds pecked at the suet in a tree stump. We watched, fascinated.

Then our attention was captured by the mountain as its color changed from brown to orange in the setting sun. Another look, and the mountain had a rosy cast. Then purple.

Smelling the marvelous aroma of grilling steaks, we followed our noses to the west patio where we enjoyed a delicious meal in the sunset's afterglow.

We returned time and again to the rugged beauty of the desert. One cool afternoon, as we were enjoying the warmth of their rock fireplace,

our hostess said, "Come, look!" We rushed to the big picture window. Our eyes followed her pointing finger and we saw beady eyes and a long snout. A full-sized animal emerged from the dry wash and approached the house. He came to the window, looked in, then quickly disappeared, leaving us spellbound.

"He is beautiful. But, what is he?" I asked.

"A coyote. Sometimes we put food out for him. He was saying thank you."

We will never go again to the adobe house in the desert, for our friends are no longer there. We wonder if the quail still appear on schedule , if the coyote is still welcome, and if the setting sun reflected on the mountain is noticed by someone.

We know the beauty of the desert and the desert creatures is lodged forever in our memory.

❂

Desert Fossils

John Ames

The sea has been everywhere.
It hugs the land, greets the moon.
There is a courtship of longing
between moon and sea.

In a time now dead
the desert married the sea.
Then fickle clouds
and fire of sun
gossiped with wicked tongues
and the sad sea ran away.

Stone images were left
for wondering minds to find—
patterns of sea life
etched on stone.

The sea has been everywhere.

Descent into the Grand Canyon

Dorothy Lykes

The stinging rain
blends odors of pungent sage
and pine as it curls
past me on the path down
from the canyon rim.

Red mud packs into balls
clinging to my boot soles.
I lose traction
on the trail—
a slippery hide—
and crouch beside a boulder
to watch huge snowflakes
hit updrafts and bounce
soft sounds off rocks.
Some pack into trees,
white accents on ancient bark.

An ocean of roiling clouds
lowers over me
and the canyon disappears
and the trail
and the trail . . .

Walnut Canyon Surrealism

Jim Krafft

Behind our yard a game trail
slithers through dry grass and greasewood.
Snaking with the path,
I enter a magic domain, where
ponderosas guard the trail on all sides
like a crowd of observers.
Deer droppings make the path certain . . .

Then there is no sign, no path,
only my compass to direct south among
tufts of bunch-grass that protrude to trip the traveler
as though to protect a sacred place.
I quiver. Soft mud reveals bear tracks.
She is just beyond that clump of gambel oak.
I believe that the ponderosas laugh, there is no bear.
I am alone, a stranger in the wilderness a mile from
 the city's edge.

The April day is grey, with snowflakes floating
here, and a blizzard on Mounts Agassiz and Fremont.
The north Walnut Canyon rim appears like a surprise;
the opposing south wall is layer upon layer
multi-colored French pastry
for a brooding giant . . . or is that rock?
On Anderson Mesa beyond the south rim in the dusk
a herd of pronghorns dances, oblivious
to mountain lions that crouch below.
From an undiscovered dwelling
strung along the cliff, Sinagua people emerge,
move like tightrope walkers on the knife ledge.
In haste I turn toward Mount Elden and home.

The plaintive gobble of wild turkey
musics into a harmony
with the wing-song of a mourning dove.
Five mule deer leap away,
then silhouetted on a promontory, a buck and a doe
stand side by side, as in a frame of cinema.
The forest rumbles just to my right, a moment of fear
as great brown blurs appear.
Crossing in front of me a bull elk
and eleven females of his kind move across the feeble sunset
into the sky.
I follow . . .

Whatever-it-was Taught Me to Dance

Vi Miller

An uninvited guest gave me a free dance lesson yesterday afternoon.

I had just finished my last chore, taking the trash out to the alley. I closed the back gate, turned around, and there *it* was stretched out on the bottom rail of my redwood fence. First I judged *it* to be three feet. . .five feet. . .well maybe two feet long.

Primeval instincts seized my senses. I began to stomp to the beat of blood pulsating in my ears. Strange chanting sounds emanated from my throat. . . the uninvited *thing* did not move.

After what seemed longer than watching the rerun of "The Call of the Wild," logic returned. Ideas began to take shape. I had better get into action soon for twilight is short in Arizona. Darkness follows rather soon after sundown.

I inched forward one step...stopped and attempted to see if I was seeing what I was not certain I had seen...then three rapid steps backward. Cha-cha-cha.

More ideas bombarded my brain. Can I make it to the house? I could watch *it* from the front gate. But I discarded them. I couldn't leave *it* in the back yard. Then the beat changed from brave to courageous. I had a better idea. I remembered the trellis that I dismantled a few days ago. The slats were about six feet long. That would give me a head start in case *it* attacked.

I side-stepped over and picked up a slat. I returned the same way.

Cautiously, I poked. The tapered, elongated *thing* seemed headless. WHAT-EVER-IT-WAS was still. *It* didn't move. I stuck the slat under *it* and heaved. *It* hung like a wet noodle. I did another backward-step when *it* plopped back onto the rail.

Time was short. But could I be sure *it* was dead? If so, I could carry *it* to the alley. Caution interjected. I remembered how possums play dead. *It* might be faking, waiting for a chance to strike. I would give *it* one more test.

I tightened my grip on the slat and slid it under the tapered end of the creature. Slowly I worked up to the thick end. Zoom! *it* shot up the fence post. Cha-cha-cha double-time.

I dropped the probe. I'd heard of gila monsters . . . p-p-poisonous! I yelled, "Help, somebody!"

Help arrived in the form of Mr. Calloway, my neighbor, and his two sons.

"What? What?" they shouted.

"Over there!" I pointed. "Is it a gila monster?"

Bobby, the youngest, said, "I can't see anything."

"It's almost the same color as the fence," I told him.

"Think I see it," Steve said. "Let's find a box to put it in."

I didn't have anything big enough or strong enough. But the younger boy had an idea. Their heavy wire mesh grass catcher would be just the right size "Yeah, when we catch it, we'll keep. . ."

"Oh, no! said Mr. Calloway. "But the grass catcher is a good idea."

When the boys returned with the catcher, he laid out battle strategy. "Each of you grab a slat, "their dad instructed. Looking at Steve, he said, "You stand on this side while Bobby stays over there. I'll hold the cage. Now boys, push it into the opening. Don't injure it!"

I wasn't included in the plan. And just as well. The monster puffed up until I thought *it* would explode. I cha-cha'd a bare spot in my lawn.

The boys parried, lunging, thrusting, stabbing. Just as the redness in the western sky turned to dull gray, *it* went into the cage. They put a screen across the opening and weighted it down with bricks. The monster would be my weekend guest.

We were not sure if it was a gila monster. We studied it from a distance. Steve ran home and brought back a book on desert wild life. Yes, it had a banded tail. The head was blunt with a short neck. Reptile or amphibian? The body was mottled. A fang on either side of its mouth? We were sure we had seen teeth. But fangs? Well, maybe.

I don't know how well the monster slept that night; I didn't. The next morning I hoped it was a bad dream. But when I peeked between the drapes, here *it* was.

Why does every emergency have to happen on Saturday night? I couldn't wait another day to get rid of that monster.

From the depths of desperation flashed the words on my grandmother's sampler: 'Action is the first step toward solving a problem.' I grabbed the telephone book and found the number of the Arizona Game and Fish Department. Even though it was Sunday, they answered promptly and promised to send someone immediately.

When the uniformed man arrived, I pointed to the cage, then followed well behind him. I went

into another dance session when I saw him reach into the cage and pick *it* up barehanded.

"It is against the law to bring one of these into town," he told me. "But people do it. Then they tire of them and let them loose. Fortunately they didn't break another law and kill it."

I shuddered. "I couldn't get close enough to it to kill *it*. Wasn't it dangerous to handle *it* without gloves?"

His smile broadened. "It's just an old chuckwalla." He wasn't smiling when he added , if it was a gila monster, I'd be respectful of that lizard." He patted *it*. "Ole feller, I'll take you home."

Oh, what a relief. I had been doing the CHUCK-WALLA CHA-CHA-CHA and not the GILA MONSTER MAMBO!

❂

Bring Me a Scorpion, Grandma

Alda Becker

When my daughter, Carol, was enrolled in Arizona State University, one of her courses was biology. A requirement of the course was that each student earn 100 points during the semester by bringing specimens to class. A rattlesnake was worth 25 points, a scorpion 15 points, a tarantula 10 points, and insects a point apiece.

She was telling a friend about it one evening and was delighted when he said, "I can get you a scorpion."

He worked for a company that installed swimming pools and said that they frequently stirred up scorpions while excavating for a pool.

He was good as his word. The next time he came, he brought her a quart jar three-quarters full of scorpions!

With great care, her father extricated one scorpion with a long pair of tweezers and put it in a small jar for her.

"I'll use some of them to make bolo ties," he told her.

After he had made several of the tie slides, he moved on to other projects, and the jar with its deadly creatures was shoved to the back of his workbench.

A year later his mother came from Seattle for a month's visit. She was a nice person but never liked to have a cat brush up against her, thought dogs were fine as long as they were outside or in a neighbor's yard, and always kept a good supply of Raid on hand for the elimination of ants and spiders.

We all laughed when she said, "What do you suppose Jim asked me to bring him? . . . a scorpion!" Jim was her 12-year-old grandson—a boy with rather strange tastes!

My husband disappeared, returning in a few minutes with the scorpion jar which he dusted off and presented to his mother.

She scrutinized it carefully and then said, "I'm going to put it in my suitcase right now, so I won't forget to take it when I go."

A month later we were all standing around keeping her company while she packed for her return trip. She took the jar out and looked at it for a minute or so. Suddenly she gasped, shrieked, and practically threw the jar at my husband, screaming, "They're alive!"

"Don't be silly," he said, but he took the jar over to the window for a closer look. Disturbed by the handling of the jar, the scorpions were crawling over each other in gay abandon.

I had wondered why the jar was only a third full. Now I knew.

Although there had been no air, food, or water in the tightly closed jar, cannibalism had provided us with live survivors.

Needless to say, Jim never received his scorpion!

✸

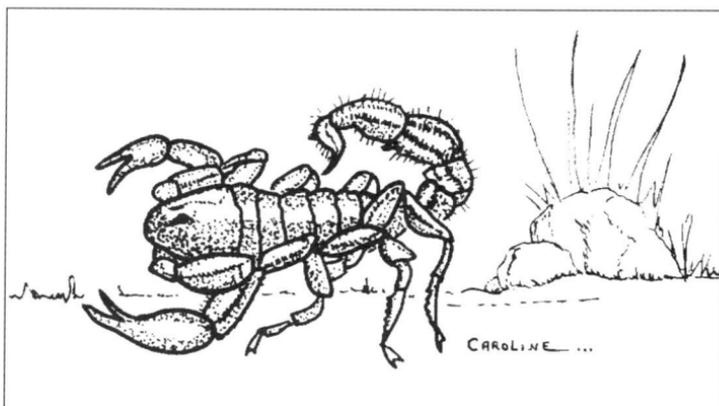

Javelina

Frances Libby

Five ugly shapes
under the moonlight
tusking up seed
beneath the feeder
prehistoric
dark as thoughts
rising unbidden
from the id
half-blind
lured by scents
no mortal smells
drawn to my purview
making me know
how islanded
civilization is.

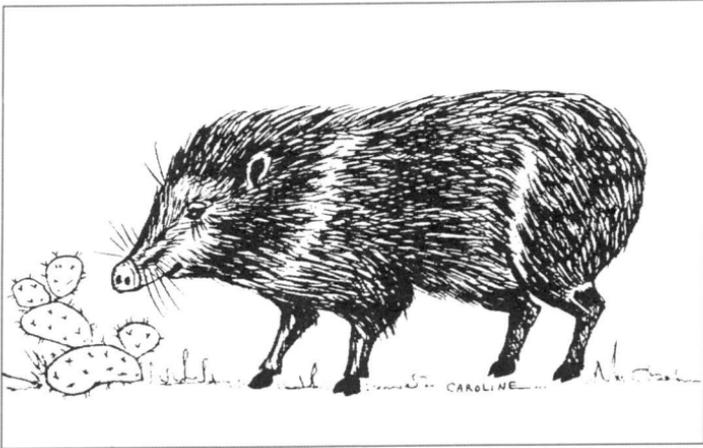

CAROLINE

Lucidity

Bob Finkbine

Curved claws
of mesquite stand watch
over the quickening
of rock nettle and scorpionweed.

The datura raises its cobra head
where time runs uphill
from black breast of schist
through epochal layers
to Moenkopi siltstone,
where ringtail cats, half-grown,
slip soft-padded by buckhorn cholla
while fat black ravens wallow in the wind.

Water masses down the drops
roaring like a wounded beast,
churning tons of river
exploding into scrubbed

scent of spray
past
cliffs and creviced slots
stretching minds
around an illimitable world,
its enclosed intricate cycles
and connective proliferation spun down
to blinking wings of butterflies
clothed in pollen
on a podded prickly pear bud
so pale and new
it is the center
of the universe.

My Cousin, A Saguaro, And Me

Lois Harbert

Not until my cousin from Iowa visited me recently did I remember how difficult some Spanish/Mexican words were for me when I first came to Arizona some thirty years ago. Not only could I not pronounce such words as *cholla, saguaro, ocotillo,* but I had absolutely no idea what they meant nor what they were.

My cousin called from the airport to say he had arrived, had rented a car, and if I would give him directions, he would be at our home shortly.

I very accurately told him how to get there, like an Iowan, with north/south and east/west directions and which streets to take.

"We're the fourth house on the lefthand side of the street as you turn west. You can't miss it," I added. "We have a big saguaro in the front yard. We're the only house with a saguaro."

Within thirty minutes, he rang our doorbell and I complimented myself on the good directions I must have given him.

After lunch we decided to take a drive in the desert as he had indicated he was very much interested in seeing Arizona. We drove north on Scottsdale Road through the desert that extends through Scottsdale, Carefree, and Cave Creek.

Along the road we saw many cacti and most species had small wooden signs in front of them to identify them. As we drove along, my cousin began to read the signs.

"Prickly Pear. . . . Hedgehog. . . ."

Then he tried to read *saguaro*, giving the "g" a good soft "g" sound. I had to tell him my story about how I, too, had to learn to pronounce *saguaro, cholla, ocotillo.*

I explained that "g" in *saguaro* had a sound somewhere between an "h" and a "w" and that the "l's" in *cholla* and *ocotillo* have a "y" sound.

"You know what a saguaro is?" I asked, pronouncing it correctly, of course. "Remember, I told you we had one in our front yard?"

"Yep," he replied. "I remember. I didn't know what it was. All I knew was that you had something in your front yard that nobody else had. I didn't know what a saguaro was from a hole in the ground!"

✸

Cicadas Sing a Phoenix Summer

Dorothy Lykes

A dome of heated sound
this chorale of insects.
It penetrates my skull,
dries on my tongue.

After seventeen years
sapping roots underground,
cicadas emerge within days
and gain footholds on walls,
citrus trees and grass stalks
where they struggle
to shed wingless nymphal husks.

Calling to mates, the male's
rasping song swells.
New eyes bulge red.
Isinglass wings with delicate veins reflect
rainbow light.

The trill increases, invades
July's nighttime heat. A constant hum
it grows into a mountain of buzzing
that envelops a resting wind
where one feather lies on the air

and the final leaf from a dying tree
spirals to earth beside cicada bodies.
In eight weeks, nymphs hatch
and burrow. The heat

becomes silent.

Where the Ghost of Eagle Woman Dances

Sandra W. McFate

The small cluster of men and women stand peering into the shadowy canyon. The full moon rising over the mesa is burnt orange, then gradually turns to buttery yellow. Stillness prevails. Across the dark chasm a gentle breeze blows and a distant coyote yelps, then stops.

One woman calls out, "There she is! I see her! I see the ghost!" A man shouts, "Look, she's dancing!"

Startled eyes view a tall, slender female figure in the depths of the canyon clothed in a flowing, shimmering gown, and illuminated by bright moonlight. The folds of the gown undulate with a hypnotic rhythm.

Is the Indian tale true? Is there a ghost in Coal Canyon?

Few people know the legend of the dancing ghost in Coal Canyon. In fact, few people are

aware of the existence of this unusual canyon a few miles from Tuba City on the Hopi Indian Reservation.

Coal Canyon or Coal Mine Canyon, as it was earlier referred to, derives its name from coal mined there over the past centuries, even before the advent of white men. The Hopis are thought to have used coal for fuel as early as the thirteenth or fourteenth centuries. This was discovered by excavation of early Hopi middens and finding coal ash. There is evidence that Hopis used coal for firing pottery as well as for domestic purposes.

Some say the Indians lost interest in mining coal when sheep were introduced and sheep dung began to accumulate in their corrals. They then used this as fuel, it being much easier to obtain than coal. But another view insists that the Indians abandoned coal mining in the canyon after a Hopi woman, who had lost her mind, leaped over the cliff to her death, and since then they believe her ghost returns to dance in the moonlight. Skeptics say it is the moonlight, reflecting from oyster beds laid down eons ago, that accounts for the illusion of movement around the tall spire rising from the floor of the canyon.

The legend of the dancing ghost persists, however, and during summer months each year small parties of people make the drive to the canyon's edge to watch the ghost of Eagle Woman—translated from the Hopi name, Quayowuuti—dance in the glow of a full moon.

Hazel Carter, former owner and operator of Montezuma Lodge near Mormon Lake, made the 110-mile trek to Coal Canyon with her guests several times a year until she sold the lodge. Considered a practical and unflappable person by her friends, Carter says, "Yes, she appears and moves. Why or how, I don't know. No one has ever been able to explain it. Geologists have made tests of rock from the formation, but have found nothing phosphorescent."

If you are not fortunate enough to be around during a full moon to see the ghost, Coal Canyon is still worthy of a special trip at any time of year. It is a gem among the scenic places in Northern Arizona. The most direct route: Take State Highway 264 southeast from Tuba City for 16 miles; look for an inconspicuous wooden marker that says " Coal Mine Canyon" and turn left onto a dirt road for a few hundred feet. Abruptly, you are at the canyon's edge.

From the canyon rim the coal vein can be seen, a large black horizontal streak banded above and below with many layers of pastel sandstone and shale. The myriad rock formations, in combinations of white and pink, red and blue, and yellow and green, create a stunning visual impact.

The bottom of the canyon is accessible by hiking down a trail that is steep at certain points, but not impossible to negotiate by one in good physical

condition. A half hour's walk takes you to the canyon floor and another glorious spectacle. Here are rock formations that have eroded over the years to resemble animals, human faces, sitting buddhas, standing buddhas, and any other object that spikes your imagination. It's a happy hunting ground for photographers.

In the bottom of the canyon the tall spire rises, giving the semblance of a human figure. According to the myth, Quayowuuti plunged to her death at the base of this formation. When her family found her, they covered her body with stones and left her there. Hopi custom is to leave bodies where they are found when death occurs away from home.

Some exertion is needed to climb to the ledge where the figure of the "ghost lady" stands, but it's worth the effort. You will feel insignificant looking upward, trying to see the top of the spire. The quiet splendor of the wondrous creations of nature will induce a languorous tranquillity.

The hike going out of the canyon takes a little longer than going down, and the last sandy stretch is the most difficult. Sand will fill your shoes as you find yourself sliding backwards with each step up. At the top of the mesa, Russian thistle and Mormon tea grow in abundance. Ignore the thistle, but gather the tea. Dried and steeped, it makes a refreshing drink with a delicate flavor.

The ghost in Coal Canyon remains a mystery. The Hopis are reluctant to talk about the legend and the State of Arizona doesn't show its location on the official road map, though it appears on a few other maps of Arizona available locally at service stations. Perhaps the state has some esoteric information that tells them the ghost of Quayowuuti does not want to be disturbed.

✪

CAROLINE

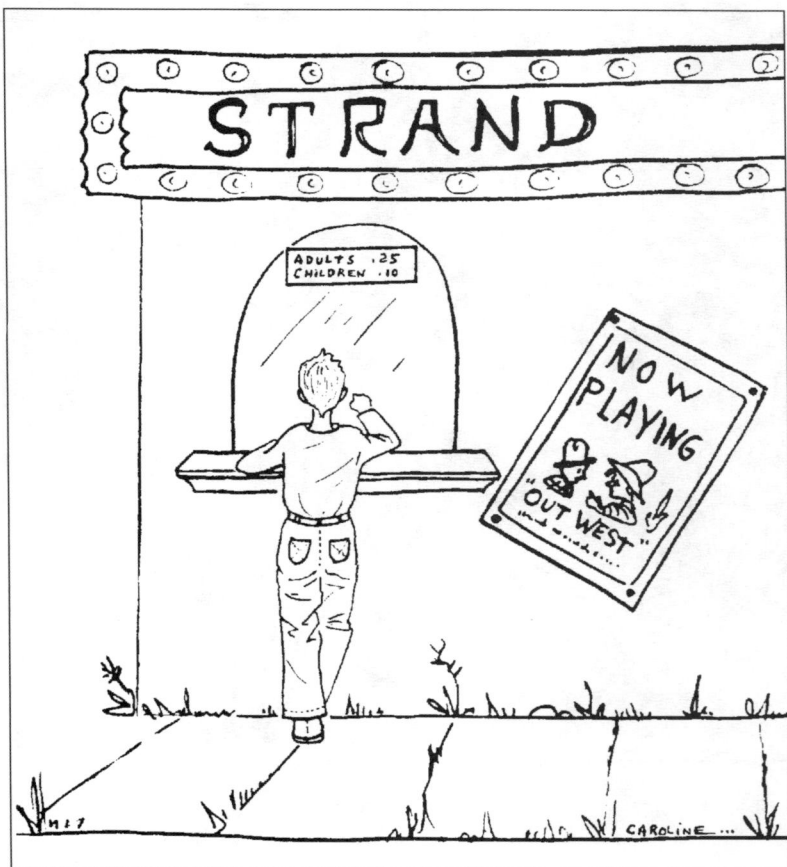

Phoenix and the Salt River Valley: Then and Now

Remember the Day

William N. Grove

The Fox. The Orpheum. The Rialto. The Visa.

The Phoenix. The Strand. The Studio. The Rex. The Ramona. With that many theaters to choose from, a movie-crazy kid in Phoenix in the late thirties and early forties had it made.

I never went to the Rex or the Ramona because they ran Spanish language films exclusively. Unable to read or speak the language, I never even knew the name of the film playing, much less understood the dialogue had I gone inside.

Except for the Orpheum and the Vista , all of the theaters were on Washington Street between Fourth Street and Third Avenue. The Orpheum was at Second Avenue and Adams Street and the Vista was on the east side of Central Avenue between Monroe and Van Buren Streets.

But without a doubt, the Fox with its massive grandeur, was my favorite. It enveloped me in the richness of gorgeous chandeliers, a wide curving staircase leading to the balcony, plush carpeting that cushioned numberless footsteps

66

over the years, and roomy ornate restrooms that were grand compared to our simple facilities at home. Walking into the lobby with your ticket in your hand on a blistering summer day gave you a feeling of relief, anticipation, and excitement. For a few hours you could be lost in the opulence and refreshing coolness of the Fox, not to mention the escape from reality that awaited you on the silver screen.

The ticket booth at the Fox advertised seats in three price ranges. The loges, the most expensive and much like today's lounge chair, were the three rows at the very back of the main floor. The remainder of the main floor seats were in the next price range. Naturally, the balcony seats were cheapest. You were always shown to your seat by an usher with a flashlight.

Shows were continuous with no breaks between. Folks didn't rush to get to a show at the beginning. People came in and out all during the movie. If you came in during the middle of the film you simply stayed until the movie reached that point again and you got up and left.

Those were the days of double features. A main feature starring Greer Garson and Clark Gable was followed by a silly, low budget film quite often about college kids putting on a musical revue. Such a flick would have a cast of much lesser-knowns like Johnny Downs, Virginia Weidler, Harriet Hilliard and Ozzie Nelson. In addition, one saw a cartoon, the *Fox Movietone News,* previews, sometimes a Robert Benchley short and periodically, the *March of Time.*

You got your money's worth. But in those days it wasn't always easy to come by the money. My family was poor, and I usually raised my movie fare by selling pop bottles at two cents each to the junkman until I got the thirty-five cents for admission.

But, oh, how wonderful to get a thirty-five cent heartthrob from Alice Faye in *Hello Frisco, Hello*. Or to spill tears over Claudette Colbert being ignored by John Payne in *Remember the Day*. Or to be scared silly by Simone Simone in *The Cat Woman*. I was one of many who were shocked at seeing loveable Shirley Temple play a spoiled brat in *The Bluebird*. The majority of movie fans, unable to perceive their little darling in such an unlikely role, stayed away in droves and *The Bluebird* laid an egg at the box office to become Shirley's first flop. But whether a hit or a flop, that thirty-five cent admission could buy my way out of holey shoes with cardboard innersoles, pants with patches on the knees, and a polo shirt two sizes too small.

You could stay and see the show over and over again. No one ever asked you to leave as long as you weren't rowdy. After all, you'd paid your thirty-five cents!

I was at the Fox on December 7, 1941 watching Bud Abbott and Lou Costello in *Keep 'Em Flying*. Mom and Dad picked me up after the show and we went on a picnic to a serene desert area north of Phoenix, now referred to as Paradise Valley. On our return trip we were startled to hear newsboys shouting the headline, "Japan Declares

War. Pearl Harbor Is Attacked!" when we stopped for the light at Seventh and Roosevelt Streets.

Nothing was ever the same after that. Movies, theaters, admission prices, stars, and censorship all changed drastically. Several of the male stars went into the service. Carole Lombard was killed in a plane crash returning from a War Bond Rally.

The sleepy little town of Phoenix in the postwar years grew to a big, sprawling metropolis. But big is not always better.

The Fox. The Rialto. The Vista. The Phoenix. The Strand. The Studio. The Rex. The Ramona. They're all gone. They have been replaced by a bus terminal, a municipal building, Patriot's Park, the Valley National Bank Center, the Civic Center, the First Interstate Bank and in some cases, by boarded-up buildings.

Only the Orpheum remains. It is in the process of restoration. The sculptured gargoyles still stand guard from the height of the exterior walls, keeping malevolent watch, staring in suspended animation at unsuspecting pedestrians crossing at the intersection of Second Avenue and Adams Street.

Could it be that they remember the day they gazed down on the throng waiting for the doors to open for the premier of *Gone with the Wind*? Or have the reverberations of restoration caused them to look forward with excitement and anticipation to the coming day when the crowds appear again, the house lights dim, and the show goes on.

❁

The Street Where We Live

Magdalene Fennell

As we entered the city, its relaxed milieu fascinated us. Drivers observed speed limits of 20 miles per hour and courteously waited their turns at four-way stop signs; rows of stately palms lined the avenues; citrus trees, heavily laden with fruit, garnished median strips; golf carts and two- and three-wheel bicycles transported residents to and from appointed rounds; senior citizens, nattily dressed in white, lawn bowled at the recreation center; dog lovers walked pets and picked up their poop; and mini shopping centers were within walking distance of homes. All this added to the magic of the place.

The street we turned onto was squeaky clean, flanked on both sides by ranch-style apartments. Each group of four shared one roof of pearl-like stones that glistened in the sunlight. Citrus trees—lemon, orange, and grapefruit—and picturesque palms with curved trunks embellished front lawns. Oleander bushes,

bougainvillea, and privet hedges hugged the residences at kitchen and bedroom windows.

At the rear of the houses, cement patios, enclosed lanais, and a generous sprinkling of fruit trees sustained the beauty of the landscape. Grass on one side, ocotillo and saguaro rooted in sand and stone on the other, provided an appealing contrast.

We had picked a good place for our retirement home. Surely, if paradise existed on earth, it was here in Sun City, Arizona. We saw. We loved. We bought.

During our before-dawn walks and sunset meanderings past lush fairways and manicured green lawns, all who met us greeted us. Among pedestrians, no stranger existed. Nothing disturbed us; not even the sudden eruption of sprinklers on the golf courses and the thorough soakings that followed.

We were royally welcomed by our neighbors, two of whom sent their pastor to see us. The couple down the street invited us to dinner. Others came bearing oranges and grapefruit. Some offered us tables and chairs for our sparsely-furnished abode. When we had to return to the East Coast on business, our new neighbors forwarded our mail, and literally flushed our toilets. We had become a part of a new and exciting lifestyle.

It didn't take us long to identify the blessings, and the curses, of our new community. Of the latter, it was the silk oaks on our block, much-

loved for their shade, but hated for their shedding. An unwritten law of the condominium association was that the leaves had to be removed—preferably while still falling or immediately after hitting the ground. They were swept from carports and driveways each morning and deposited in trash receptacles built into the ground. This provided the opportunity for neighbors to lollygag about very important matters. That is, to explain to visitors that five straight days of rain were not typical Arizona weather, to critique the topiary hedge being started up the street, to discuss the crime committed ten years ago when someone removed a rake from someone else's utility shed and never returned it, to recommend pesticides for the insects congregating on rose bushes, to bitch about the sloppy work of the gardeners, and to appraise the remodeling job of another neighbor's bathroom.

But, three months into our relocation adventure, the devil invaded our paradise. He appeared in the guise of an anonymous letter.

Dear Fennells:

Your neighbors are very unhappy that you moved in. Please do all a favor by selling and moving in near your own people. We're all old, having lived here for 20 or 25 years, and do not have anything in common with Black people. Please leave us in peace

with our own. You would enjoy life a
lot more with your own. This
way, all would be happier. We don't
understand or know anything about
Blacks. Please leave us in peace.
There's too much trouble in the
world already without adding more
stress and strain. We hope you'll
understand

Thank you!

The arrival of the letter gave us occasion to recall our interview with the condominium association. Held prior to our settlement, it turned out to be an intriguing process. We had noted shock on the face of the officers as we entered the room and sensed their discomfort as they fought to recover from the trauma of our presence. When most of them became mute there was a role reversal; and we became the interviewers, they the interviewees.

Near the end of that early question-and-answer session, a talkative latecomer rushed in and immediately began a litany of experiences, trying to convince us that we wouldn't like Sun City.

The summers were so hot they were unbearable, she said. We wondered why she could survive those 115 degree temperatures and we could not. This was never addressed.

The next day, while we were visiting our realtor's office, the phone rang. When the agent answered, she said, "I didn't tell you they were Black because

it had nothing to do with their purchasing a house." Her answer revealed the caller's question. Obviously, it had been asked by someone in attendance at the association meeting the previous day.

Now we spent hours and days trying to determine who the writer of the letter might be. Deviously, we gathered handwriting samples. None matched that of the letter's writer. We made a list of possibilities and eliminated them, one by one. We showed the letter to fellow condo owners and asked them who they thought wrote it. We searched faces and analyzed the dialogue of those we knew for telltale signs. But the identity of the culprit did not surface.

Having failed in our detective work, we concocted another way to express outrage to the correspondent. We made copies of the original missive, drafted a response, and stapled them together. We hand-delivered them to each household on our side of the street.

> To the Coward Who Wrote the Attached Anonymous Letter:
>
> No one except you has expressed any unhappiness over our move into this neighborhood. We love our new home and are very happy in it. If our presence makes you uncomfortable, the solution to your problem is in your letter. YOU SELL. YOU MOVE TO AN AREA WHERE THERE ARE NO BLACKS. Be

warned! Such places are becoming harder and harder to find.

Contrary to your opinion, you have much in common with us: a heart that beats, eyes that see, ears that hear, a God who created us both. In fact, the only differences existing between us are color and attitude. We are brown; you are not. We judge people by their character; you do not. Having endured racial hatred and harassment all our lives, we know a lot about whites like you. Since you know nothing about Blacks, if you will contact us, we will school you.

Sincerely yours,

The Fennells.

Six years have passed since the postman delivered that piece of hate mail. All along we assumed the writer was someone in our condominium association. Recently we learned that a person on the street behind us had probably written it. A comment she made to one of our neighbors established her as the prime suspect. Ironically, she never saw our response. She never will. She died last year.

We have established many satisfying relationships with those in our block and in Sun City at large. Our neighborhood is as beautiful as it was when we first saw it. We treasure our life in the Valley of the Sun and plan to spend many productive years on the street where we live.

Phoenix Time Machine

Jeanne Resnick

In the Arizona Biltmore parking lot last week
impossible but true It had to be a
time warp or a crazy deja vu —
A Buick convertible vintage 1937
gun metal gray chassis leather upholstery
long low lean lines wire-spoked wheels
running boards and rumble seat —
Our first car! Bought just before our wedding
back East half a century past
A twin? a clone? a phoenix risen from the ash?

We paid twelve hundred dollars
our total wealth combined
Low mileage mint condition
Oh that car had class!
With the top down we let the dog ride
on the shelf behind the seat
She fell out once suspended by her leash
a bad moment she recovered

War came you left to serve
and luckily returned
On a small supply of rationed gas I drove
the car to meet you Our first baby
in the basket where the dog had lain before
The Buick nearly shook apart on our
farm-to-market road Still looked great
though with its new rag top let down

Our third child forced the change
Too chancy for children in the rumble seat
We gave up class for room hard lines
Sold our car to actors who had an eye
for style bought a Kaiser early hatchback
with space to spare for kids ourselves
the groceries and hay for the horses too

Forty some years later
in Phoenix at the Biltmore
an eccentric antique auto buff
retrieved for me unknowingly
a portion of my youth

Tent-House Adventures

Lillian Risner

The year was 1918. We had just arrived in Arizona from western Texas, and were living in a tent under some large cottonwood trees that grew along a ditch bank. The leaves on the cottonwoods were turning gold and falling one by one into the water, reminding us that the weather would soon turn cold.

My father had obtained some virgin land near the South Mountains that had never had a plow put to it and the first business at hand was to build a better place to live. We knew we couldn't live in the tent during the winter.

We decided to build a tent-house, which was very popular at that time. It was not only inexpensive; it could be built quickly and easily. A wooden floor was laid on top of some two-by-fours and a wall of boards three-feet high was built around the edge. Then a tent was stretched over the whole thing with the bottom edges secured to the wall. A wire screen was attached on one side under the tent so that the tent flap

could be raised during mild weather. My father built two of these facing each other and about four or five feet apart. A large waterproof canvas was stretched from tent-house to tent-house forming a cozy area. In this he built a fireplace with adobe bricks he made from the soil. A Mexican man, who lived on a farm across the road, furnished the straw for the bricks and taught my father how to make them.

The fireplace became the center of activity. The aroma of mouth-watering gingerbread floated from the Dutch oven. Whitewing doves my father shot from the cottonwoods, and which my sister and I had to pick and clean, simmered in an iron pot. Finally, everything was cozy. And just in time, too, since my mother was expecting a baby.

Amid all this activity, I was sent off to school. It was a one-room building with a bell on top that rang out over the countryside telling us it was time to start to school. I could see the school at the end of the road with South Mountain in the background. Even though it looked close, it was about a mile-and a-half away. The walk was a fairyland with bright green alfalfa fields on either side. Along the road was a row of trees laden with large, white, sweet-smelling blossoms. Some said they were magnolia trees brought from a southern state. Cattle fed in the fields and sometimes a bull bellowed and pawed the earth. When I looked at the few strands of barbed wire that separated the bull and me, I usually ran the rest of the way to school.

Our teacher, Miss Rose, a tiny woman with white hair piled high on her head, was always waiting for us. She would begin playing a march on the old pedal organ and the ten or twelve pupils would line up and march to their seats. The first order of business was the Pledge of Allegiance and then Miss Rose would say a heartwarming prayer, asking especially that God bless our men overseas and that the war would soon end. School was exciting for me, and I always went home with my arms full of books. I could hardly wait to read all about Bre'r Rabbit and the other little creatures.

Soon influenza became epidemic. Whole neighboring families were dying. No funerals were allowed. Only my father could go into town to buy supplies and he had to wear a mask over his nose and mouth. No gatherings were permitted, and the happy school had to close its doors.

For me, this was not so much of a calamity, since early each morning Miss Rose would come by in her pretty, horse-drawn buggy. It was a thrill to have her all to myself, so cozy in the buggy. She taught me numbers, listened to me read, and gave me an assignment for the following day. None of our family caught the flu.

Our oldest brother was born in late October. The doctor came to our tent-house, and all went well.

The following summer, two frightening events occurred. It was warm weather and both my father and mother were busy outside. It was my job to straighten up and prepare lunch. We were eating when my father ordered all of us to pull our feet up into our chairs. He had just heard a rattlesnake under the couch on which my sister and I were sitting. We found the huge snake, but it managed to get away through a tiny opening in the corner of the tent-house. No one could possibly believe that such a huge snake could slide through. My father made sure this opening was closed for keeps.

Later in the summer there was what we called a "mad dog" scare, which was very common in the Valley at that time. Word got around fast, even without the news media. We were almost afraid to go anywhere. Workers out in the fields kept weapons handy. Groups of men tried to hunt the poor animal down. Often it could be heard down by the river struggling to drink. One morning it came through our yard as my father was washing his face and hands. The water and basin were on a bench, so my father jumped up on it and swung at the dog with the pail. Luckily it trotted off in its agony. Later it went into a field where several men were working and they managed to kill it. But we had to be on the alert because a rabid animal often infected other animals.

The year filled with troubles passed quickly and we settled down and began to do some special

things. One of our favorites was going into the "city" that consisted of about four blocks where Washington Street and Central Avenue crossed. It was always an all-day excursion. We would ride our horses into town early and leave them in the wagon yard at the corner of Jefferson Street and Central. Here the horses were kept and fed while we explored.

Early in the morning, the city seemed to come alive. Horse-drawn delivery wagons were everywhere. The clip-clop of the horses' hooves on the pavement was the theme song of our day. It meant excitement, special treats, and strange sights. One of our favorite spots was the ice cream parlor in the old Ford Hotel. Here we could eat ice cream in pretty glass dishes and look up at the big ceiling fans that waved back and forth. At noon we sat on the grass in the park across the street from the old Boston Store and ate crackers and cheese. Sometimes we were brave and sat at an open cafe counter and enjoyed a bowl of homemade chili. Young Indian men walked the streets in their Levis, their long hair hanging down their backs, and beaded bands around their heads. Indian women in long, colorful dresses sat on the sidewalks along with their small children. Beautiful jewelry and pottery were spread on blankets before them. Too soon it was time to go home and we started for the wagon yard.

After all these adventures, we finally moved to a ranch out in the country west of Phoenix. For months I was heartbroken. At night I cried on my pillow, seeing again the bright alfalfa fields with cattle grazing, the little school at the end of the road, and the sweet-smelling flowers on the trees by the side of the road.

❁

Don't Ask Me In August

Caroline Haines Burke

If you lived on the corner of 16th Street and Van Buren today, you would be surrounded by a Jack In The Box, an automobile repair shop, an adult book store, and two used car lots. One of the used car lots—still owned by the same family—was there when I arrived in Phoenix in 1947. Citrus Drug Store is now the adult book store.

The corner of 16th Street and Van Buren today bears little resemblance to the quiet, tree-lined street of the late 1940s with its small red-brick houses and friendly neighbors, who, like me , had come to Arizona from somewhere else.

I had come, not by choice, but to be with my mother who had arrived a few months earlier to care for her sister who later died of tuberculosis.

After graduation from high school, I had packed my few possessions, kissed my dear Aunt Anna goodbye, boarded the train in Philadelphia, and reluctantly bid adieu to everyone I knew and loved on the East Coast of New Jersey. I spent the three-day train ride across the United States

in tears. And even though it was good to see Mother again, my rude introduction to Phoenix as I stepped from the train onto the platform was a blast of hot air straight from the bowels of hell that smelled of dust and engine oil. I hated it.

Mother's little house, however, was welcoming. One of six small brick cottages, it was nestled behind the drugstore among fruit-laden citrus trees in what was known then as Twining's Auto Court. As I remember it, very few of the tenants owned an automobile, and almost all of them were "year-rounders." Year-rounders were renters who, to their landlords' delight, stayed in Phoenix for the duration, unlike the winter visitors who flocked into Arizona in the late fall and flew the coop in the spring, long before temperatures reached 90 degrees. After that, rentals all over the Valley sat empty during the long, hot summer.

I spent my first week in Phoenix sprawled on the relatively cool cement floor in Mother's dining area in front of the window cooler. Unable to eat, I could only pour gallons of iced tea down my parched throat while I cried bitter tears and counted at least fifty reasons why I never should have left New Jersey.

The window cooler was a necessary, but strange device. Before the mid-'30s, in an attempt to survive the brutal summers, sweltering Arizonans draped wet cloths over open windows or set electric fans behind large blocks of ice. I've often wondered what the poor souls did before

electricity. The invention of the window cooler was a gift from the gods. The principle behind it is simple, and the pioneers almost had it right. The cooler is nothing more than a box containing a fan that blows over or through pads of dampened straw, cooling the air by evaporation—not unlike nature's own cooling of the human body by perspiration.

The cooler's blast of air, in the days before cooling ducts, blew into only one room. Unless one stood or lay directly in front of it, it had little effect on the relentless summer temperatures. The difference was that the air actually moved; and instead of the dry, dusty smell of the outdoors, the house was permeated with the aroma of cool, wet straw. I would have been the first to admit, however, that it was a fantastic improvement over a wet blanket or a fan and a block of ice.

August in Phoenix and the surrounding valley in the '40s was not only unbearably hot; it was as culturally barren as the surface of the moon.

Where was the library? Were there any museums? In this desert would I ever again see a pine tree or pick the wild purple violets I used to come upon in the New Jersey woods? And where, dear God, was the scent of the sea? I was not only homesick; I was heartsick. I had been condemned and sentenced to die in this forsaken place.

One day, before that August was completely over, I picked myself up off the floor, and grew up.

Most evenings in the court, neighbors carrying their folding lawn chairs, converged on a cool, grassy spot beneath the canopy of grapefruit trees. It was storytime and we listened and nodded in understanding as we shared individual and widely varied situations that had led to our pulling up beloved roots in cities, towns, and farms across the country to venture West.

After dark, Mother and I walked to the drug store for ice cream sodas or to buy groceries at Louie's Market, lighted on our way by small incandescent bulbs that danced and bobbed on their wires above the used car lot. Sometimes a red dust rolled in with a stirring wind from the South, carrying the promise of rain. More often than not, it was only a promise.

On those occasional mornings when it was cool, we walked one mile north. Small brick or stucco houses in the shade of palm or citrus trees lined both sides of 16th Street almost to McDowell Road. About four blocks east of 16th on McDowell, the pavement ended in front of another court—a

cluster of tiny, ramshackle, frame cabins painted green, hunched in the dubious shade of tamarack trees. Beyond 20th Street on East McDowell, civilization seemed to end. The desert remained unclaimed and virtually uninhabited in those outlying areas known to the old timers as "the toolies".

* * *

Forty-six years later and several miles away, you might occasionally find me sprawled on the coolness of a tile floor on a hot, humid August afternoon, iced tea in hand.

Now, when the promise of late summer rains is fulfilled, I breathe deeply of the scent of the desert sage and creosote, and that instantly recognizable, mysterious aroma of parched soil opening to receive this miracle.

Beneath a tall pine tree in my front yard, I tend small green clumps of heart-shaped leaves that will present me with pungent purple violets in January. And sometimes, on a hot summer day, I sit by my backyard pond, watching small fish dart in and out among the rocks beneath the water. I have been known to spend hours in libraries across the Valley. I frequent the many museums all over Arizona absorbing the rich history of this Southwest and its early civilizations. And if someone were to ask me, I could probably count at least fifty reasons why I've decided to stay in the desert Valley.

Just don't ask me in August.

A Rainbow For Phoenix

John Ames

There is the smell
of street dust
before the rain.
The day unravels
summer turns to heat.

Then thunder heavy-footed
runs through the clouds
like an angry elephant.
The ground shakes.

Fresh air stiff at the edges
pours into the street
brightness a jagged
branch of light
whip-cracks the sky.

I wait
with a wish
for a rainbow.

Hot Times in Early Phoenix

Pat Wasielewski

In the early days of Phoenix, getting a good night's sleep without any cooling during the height of summer was a challenge. Through the month of June, the weather was usually dry. There were fewer paved streets and buildings to retain heat, so by nightfall the town was reasonably cool. By evening, with the help of a gentle breeze, one could drift off easily.

The humid months of July and August required more ingenuity on the part of the sleeper. With only electric fans for cooling, sleeping indoors soon became prohibitive. Sleeping cots in many Phoenix yards were a common early-morning sight. These had to be hastily removed some nights because of dust storms or rain, but the more bearable outdoors temperatures made sleeping there worth the risk. Mosquito netting was a requirement as protection against the attack of those droning little pests.

We were fortunate to have a yard surrounded on three sides with large oleander hedges. About thirty feet from the back of the house was a free-standing screen room with just enough space for two double beds. This building had a wooden frame covered on four sides and the top with screen, and a dirt floor. There were about eighteen inches between the beds and an equal amount of room at the foot for passage. The sheets could be stripped off easily for a hasty retreat indoors in the event of rain. When this happened, we covered the mattresses with large pieces of canvas kept on the foot of the beds for that purpose.

Before retiring on the most uncomfortable nights, we lightly sprayed the beds with a garden hose to cool them. Spraying in this manner was also a good way to wake late sleepers in the morning, but a practice that was frowned upon. I once did it to my visiting cousin who had been out late with her boyfriend the night before. A strict lecture from my mother brought a quick repentance.

We lived on McDowell Road, which even then had a considerable amount of traffic. The sounds of passing cars, the early arrival of the milkman, and a woodpecker pounding on a metal chimney made our backyard less than conducive to sleep, but the thought of intruders or danger never entered our minds.

My father was a light sleeper, so he slept indoors during the summer. With the aid of an electric fan, he was comfortable at night in the

one downstairs bedroom. Because he had to work the next day, he was unable to take a nap to make up for lost sleep. My mother, my sister, and I chose to spend our nights in the screen room rather than the quiet, hot bedrooms upstairs. Many afternoons we would lie on the living room floor and take a little siesta with fans blowing on us.

There were some nights, however, when sleep was virtually impossible. On several of those occasions the three of us, after lying awake for hours in the stifling heat, would sneak into the car and go for a ride. King, our big German shepherd, who faithfully kept watch outside the screen room, went with us. My mother would quietly back the car out of the long driveway with the lights off in order to not alarm our father asleep indoors.

With the windows rolled down so we could feel the hot breeze, we temporarily forgot our discomfort as we rode around the neighborhood. When we came back home and went to bed, we fell asleep from sheer exhaustion.

❂

We Really Should Have Burros

Lewis R. Burch

In Phoenix in the early '30s, you could ride the streetcar from 16th Street and Washington all the way to the State Capitol for a nickel. Every Saturday morning my brother and I would go to the library and the cowboy matinee at the Strand Theater (it cost a nickel, too). But it was depression time and my family was running out of nickels. My mother would give us each a dime for the streetcar and the movie, but my brother and I walked so we could spend our nickels at Wood's Ice Cream Parlor right next to the Strand. I learned to read watching the silent cowboy movies while my brother translated. Hoot Gibson, Tim McCoy, and Tom Mix were our favorites.

The nickels finally ran out altogether and the bank foreclosed. Our forced exodus to the Bradshaw Mountains out toward Wickenburg was not so much a disaster as an adventure for an eleven-year-old and his thirteen-year-old brother.

We didn't have horses like the movie cowboys did, but my brother found an answer.

"I got him! I got him!" my brother shouted. "Come help me!"

"I think that burro has un-treed your brother," my mother said. "I think we had better give him a hand."

My brother was un-treed, all right, but he had the burro. He had crouched on the lower limb of a huge mesquite, lasso in hand, since early morning, waiting for an unsuspecting burro to walk under. Now, late in the afternoon, the trap was sprung. In the first bolt of terror, the "victim" jerked his thirteen-year-old tormentor right out of the tree. But my brother was hanging on. Yelling. Running. Falling down. Still hanging on. My mother grabbed the rope and got it snubbed around another tree.

"Get on!" my brother yelled. "I'll let you ride him."

"Naw, you caught him. You can ride him first."

"He's had enough action for the time being," Mother said, looking at me. "You get on him."

Could this be my mother? I thought. I clambered on.

"Turn him loose!" she screeched in true rodeo fashion.

The burro didn't buck, but it started out on a stiff-legged run, then stopped with a suddenness that threatened to sandpaper through my Levi's. He lay down and tried to roll on me, then jumped up, and went sideways. Then he started that running and stopping again. I think we crossed Castle Creek three times. The last time across, I was underneath his neck hanging on with a scissors hold and a bear hug. Later, when my brother asked why I rode like that, I told him I was just resting my rear end.

That burro got away and he never came near our cabin again, but we caught others still remaining from the old mining days, and made pets of them. We found some old packsaddles and went up and down the wash gathering firewood. Once we rode all the way down to Castle Hot Springs Resort. Some tourists took our picture and a lady gave me a nickel. My brother made me give it back because he said I hinted for it.

The clapboard walls of our cabin had lots of cracks. We sealed and papered them with pages of old "Ranch Romance" magazines we found. My brother and I both missed the library and filled our need for reading material by reading these

pages all around the walls. The stories didn't make much sense because we could only read one side of the pages, but that didn't seem to matter very much. The stories on the ceiling provided the greatest challenge.

Once I wrote a laborious letter in answer to a lonely-heart girl who wanted an Arizona cowboy for a pen pal. She never answered. Maybe I shouldn't have mentioned my age or my burro. I guess an eleven-year-old on a burro wasn't very romantic.

We rode our burros up on the mesas above the creek bed and looked for Indian relics. Many times we found rock manos or matates that the Indians had used to grind corn. There were always broken pieces of pottery around and what we thought were tiny arrowheads.

One of the Champie boys who had a ranch a couple of hills over, offered to give me a horse. But the first time I got on it, it bit me. So I got off and told him I would stick to my burro.

From time to time we rode to visit old Mr. Hahn who had a shack a little way up the creek and who called himself the Mayor of Briggsville. Mr. Hahn would tell us stories for hours and even after we left, he would keep on talking. Mother said he did that because he was lonely. He was the one who told me he could remember the stage coming right up that creek bed on its way to Phoenix.

Several years ago, when my own son was eleven, I took him up to Castle Creek to show him where his dad and uncle had ridden the burros. Our modern car was built too low to make it up the wash, so we climbed a hill and I pointed off into the distance.

"Up there, son, is where your uncle and I used to ride."

He squinted at the hills where I was pointing. "I'd like to go up there, Dad," he said, " but we really should have burros."

I squinted with him for a long time, and then I said, "You're right, son. We really should have burros."

✸

His Studio/Home in Mesa

Helen K. Jones

El Zarco Guerrero's walls hold
handmade masks. "There's magic
in the mask," he says. His
painted guardian spirits have
fur collars for hair, horns above
ears, and lobes adorned with
necklaces. Through one long year
El Zarco carved aged cypress
into masks with a Japanese master.
Few words cut into silent hours.
Five Noh masks catch light
and shadow. The first face
shows subtle changes when worn
onstage. The next mask portrays
transition from womanhood to
demon. A samurai's face
separates her anguish from
the goblin trickster Obeshimi,

guardian of lost children.
Beside him hangs Gamineri,
half-man, half-dragon; baring
canine teeth. As Zarco talks,
gestures highlight chiseled features—
a perfect nose, high cheekbones:
his family's faces.

CAROLINE ...

Other Places, Other Times

Warm Feelings on a Cold Night

(Fiction)

John F. Schwartz

It was early afternoon on Christmas Eve when Mr. Hoops, editor of the *Daily Miner,* Arizona's first daily newspaper, bade employees a Merry Christmas and left his office, heading into Prescott's Cortez Street.

The December 24 issue had been put to bed early because of the holiday. The editor anticipated an enjoyable evening away from the cares of getting out the paper, the hectic routine of writing and rewriting against pesky deadlines, and the struggle with bulky presses prone to breakdowns. He was a bachelor, normally not one to make much of holidays—especially religious ones. With no one waiting by a warm hearth in a holiday-bedecked home, he planned to stop at the Palace Bar for a drink or two with friends. Perhaps he would play a few hands of cards. Then he would be off to the Juniper House Restaurant for a Christmas Eve repast.

Earlier in the day, the restaurant's dishwasher had been sent by its proprietor to tell Hoops that a fresh shipment of oysters, his favorite food, had arrived from the coast. But Hoops had one quick errand before heading toward the Palace on Montezuma Street. He had a proof sheet to drop off at Gardiner's Store, the town's leading general store and one of the paper's major advertisers. Crossing the street, he was aware of one of the few benefits brought with the winter. What had been a messy quagmire of mud only a few weeks earlier was now frozen into deep ungiving ruts.

Inside the store, warm and cozy thanks to the potbelly stove and the aroma of holiday goods, Hoops hurried past the folks doing their last minute shopping to find Gardiner who was busy at the cash register. The men murmured hurried holiday greetings as the proof exchanged hands. As the editor retraced his steps across the oiled wooden floor, he brushed against a small boy, nearly knocking him down.

"Oh, excuse me, son," he apologized. He noticed the boy was trying to retrieve something that had been jostled out of his hands. Hoops saw that it was a doll and said, "Say, that's not something a boy wants for Christmas, I hope."

"No sir," the youngster said shyly. "I was thinking of my sister. My little sister."

"Well, That's more like it." He patted the boy on his head. "And do you suppose your folks will buy it for her?"

"No," was the timid reply.

"Well, I guess they've already picked something out for her."

"No. Nothing. It's just the three of us now. My ma, my sister, and me. There isn't any money for toys."

"What happened to your pa?" the editor asked.

"He went off to find gold two months ago. He hain't come back."

Hoops nodded knowingly. It was a familiar story for these parts. The gold fever. Then the disappearance. Maybe lost in the wilderness, perhaps killed by Indians, or maybe just not intending to come back.

The craggy old editor surprised himself when he took the doll from the boy's hands and said, "Let's buy this doll for your sister." As he spoke, he glanced at the price tag and reckoned he could afford two dollars for a good deed.

"Oh, no sir," the boy objected. "I'd get it from Ma for asking you to do that."

"You didn't ask me," Hoops said emphatically. Then, as he headed toward the cash register, doll in hand, he suddenly stopped and spoke again to the small boy tagging after him. "And what were you hoping for Christmas?"

"Oh, nothing, really. Ma says I'm man of the house now."

"Well, being the man of the house doesn't mean you have to go without a present. What would you pick if you had your choice?"

The small boy brightened. "There's a tin drum on the counter over there. But I couldn't ask."

"You didn't ask. Go fetch it."

When the two emerged from the store, the boy turned to the editor and asked, "Could you come home with me?" He paused, then added, "To tell Ma how I got the gifts. Otherwise she'll think something awful."

"Sure I can," Hoops smiled.

The boy led the way to a small, modest house on Granite Street. After the boy told his mother, in a gleeful rush of words, what had happened, and Hoops had modestly acknowledged the story, the woman repeatedly and profusely thanked him until, embarrassed, he changed the subject.

"It's cold in here. Has your fire gone out?"

"No. I'm . . . I'm out of wood," the mother replied meekly.

"Well, that won't do. I'll go and see about some wood and while I'm at it, do you have a bird for Christmas dinner?"

"No, I'm afraid not."

"I'll see to that, too." Dismissing the woman's protests, he quickly departed.

When he returned shortly, he was carrying a dressed goose from the butcher shop. After giving

directions to the driver of a wagonload of firewood, he took the bird to the kitchen, then went outside to split wood. The boy joined him to help, and soon the two came into the house, huffing and puffing, arms laden with kindling.

It wasn't long until a roaring fire had chased the chill from the little house. Then the grateful mother set out food to heat on the stove top and invited the editor to join them for beans and bread. "That's all we have. Oh, we have fresh apples, too."

The editor pulled his Hamilton from his watch pocket and consulted it. It was getting late. Then, putting aside the thought of the fresh oysters awaiting him at the Juniper House, said, "It sounds good." He was very comfortable in the growing warmth and the beans, just beginning to bubble on the stove, smelled good.

Later, when he left for home, he was surprised to find that a thick snow was falling. The ground was already white and it had grown much colder. But he was feeling very warm inside—warm with the invitation to come back the next day to share the roasted goose and watch the children open their presents, and warm from the children's hugs, something he had never before experienced. He trudged away through that curtain and carpet of white, feeling very good.

❂

Yavapai Homestead

Frances Libby

Five miles from Whiskey Row,
a far piece, Josiah knows, in 1898,
break-back hours across the unknown hills,
dust drabs overalls, cakes on his face.
Slat bonnet fends the sun from Hannah's skin.

Wide meadow, wild with daisy, lupine,
hemmed with pine. *Here*, Hannah says,
right here. He stops the sweating mules,
sees a spring, tracks of javalina, deer,
folds the place into his mind, pounds the stakes.

One room built before snowfall,
firelight on a patchwork quilt,
winter piled outside. The barn,
lording a hayloft high above the house,
reeks of gathered crop and dung.

Shaggy horses, snorting winter breath,
curvet in the stout corral, on edge
to spell the stagecoach team
down a barely-broken track
to one more solitary stop.

Hannah beats the flour into starter batter,
kneads the dough, stirs
the beans and boils the coffee black,
singing to herself a stove-warm song,
eager for the coming stage.

Each year the house sprouts another wing,
holds another milky mouth.
Seasons strip the cottonwoods
and leaf them out again,
tuck generations into final beds.

This house, where my daughter now comes home,
is gentrified beyond Josiah's dream.
Still Hannah's meadow is awash with bloom,
well as sweet, barn as tall.
Wind, teasing trees, murmurs Hannah's song.

A Window to Throw it Out

Charles Still

While we lived in Missouri, my sister and I decided to attend a western university. She was in graduate school and I was just out of high school. We looked forward to living in Los Angeles even though it meant a long drive twice a year. There were many adventures in driving across the West in the 1920s, and we had our share of excitement. Just driving a 1925 Maxwell over the rough, poorly marked roads on these trips was an adventure.

The state that consistently produced the most interesting series of situations was Arizona. Arizona had the fewest auto repair garages and some were accomplished rip-off artists, even in those days. They also had the highest priced gasoline—as much as thirty cents a gallon. My sister and I became quite adept at changing tires and making minor repairs.

On our first trip back from the West near Yuma, we drove over the infamous board walk—a strip of about ten miles where boards were wired together so as to float over the shifting

sand dunes. The road was the width of one car, and passing zones were about a mile apart. If you met another car, you might have to back carefully to the nearest passing area and if you made a mistake, you might end up in a king-sized sand dune.

In those days Arizona was still a young state and cowboys were getting off horses to drive cars. This meant that anything could happen. Once when we were driving near Tucson, the driver of a small car loaded with cowboys decided to play games with our Maxwell. On nearly every stop, they came up behind us and, roaring with laughter, gave our car a hefty shove. Finally I let them pass and I, in turn, gave their car a fairly vigorous nudge. Fearing they might not see the humor in the new turn of events, I gave the Maxwell full throttle and left the area as quickly as possible.

On another occasion, near Gila Bend a car with side curtains in place so we could not see the occupants tried several times to force us off the road. I spotted an all-night filling station and got there in time to avoid being hijacked.

There were many other interesting and exciting occurrences during our trips across Arizona, but the one that stands out most vividly happened in June of 1927. We always tried to see as many interesting places as possible and, not being in a hurry this time, we decided to visit the Grand Canyon. We spent the night in Needles, following the route that later became famous as Route 66.

The next day, still following the route , we drove through Oatman Pass to Kingman, Seligman, Ash Fork, and on to Williams, the gateway to the Grand Canyon from the West.

We had started early to avoid some of the early summer heat, but with the rough roads and a car that tended to overheat, we were hot, tired, and caked with dust by the time we arrived at Williams. As we entered the town, we saw a sign that it was Rodeo Week in Williams.

Since my sister and I did not share rooms, we always looked for low-cost lodging. We found such a place over a hardware store where a dozen rooms had been turned into sleeping quarters. After climbing the stairs, we located our separate rooms and found the women's and men's restrooms but no running water in our rooms— just a basin, pitcher, and porcelain "jar." We facetiously referred to these facilities as "earthquake hotels: a *jar* in every room."

I was tired and dusty and used the whole pitcher of water to wash up. The water basin was completely full and it was a long way to the men's restroom where I should have dumped it. On the spur of the moment, knowing we were on a side street, I raised the window and threw the contents out. Unfortunately, three cowboys below dressed in their rodeo best, received the full benefit of my action. With much shouting and swearing, they began to run, and I knew they were on the way to take care of the perpetrator. I also knew there was no way out of the building except by the

stairs. I felt sure they would check all the bedrooms, so I made a mad dash for the one place I hoped they wouldn't check—the ladies' restroom.

The shouting and running took over the second floor of our hotel, sounding like an angry mob instead of just three cowboys. I heard them knocking on doors. Since empty rooms were not locked, I heard several doors slam. I even heard them talking to my sister. I hardly dared breathe as I sat in the darkness, and when they checked the men's restroom, which was next door, I was overwhelmed by terror. I was sure they would try the ladies' restroom next. For some reason they did not. I still had a major worry—some woman might need to use the facility before the cowboys left. Fortunately, after half an hour, they left. It seemed like several hours to me.

I waited awhile longer before I cautiously opened the door and tiptoed to my sister's room. I told her what happened and we decided I should remain in her room for the rest of our stay. She said she would get a bite to eat and bring food back for me. We decided to get an early start to the Canyon the following morning, because I am sure I would have been recognized. After tossing the water on the cowboys, I had looked out the window.

I was enormously relieved when we left Williams at daybreak and headed for the Grand Canyon. I still wonder why those cowboys didn't check the ladies' restroom.

✪

Navajo Mother at Shiprock

Dorothy Lykes

I watch my daughter skip
along the mound of debris
left from the uranium mine
as I herd the sheep and goats.

Her waist-long pigtails dance.
She practices stalking her sister
who is hiding in the entrance
of the abandoned mine. Dust devils
pick shards from the dirt road
and flick them at us and at the animals.

I stare at giant red rocks
against a searing sky—
memories burn of hearing
my husband's strangled breath
last night. For two years
he has not been able to rise
from the mattress, or dress himself.
Half of the men who worked with him
in the uranium mine are dead.

not to eat the sheep I tend
or we would look like our dogs—
skeletons with a skin covering.
The dogs no longer help me herd,
nor hunt rabbits or ground squirrels.

Long ago white men
paid bounties for dead Indians,
Indians they killed quickly.

The Prescott Fourth-of-July Boot Race

Frances Libby

We wait by the sun-whitened street
between the square's elm shade
and Whiskey Row saloons.

Something old begins.

I have seen its genesis.
Photographs like Matthew Brady's
hang on a barroom wall.
Raw-boned boys, today
more at home on Harleys
than on horses, line up,
some in borrowed boots.

A bullhorn's bray
names each with playful insults.
Blue-jeaned girls, babies hip-slung,
crane from the curb to wave.

A gun sends the runners lurching
down to the finish line,
where winners are accorded
beer can-shaped awards,
and then a politician makes a speech.

The scattering onlookers
swirl in patterns on the grass,
ripe with boot-shod memories
of a time they never knew.

Cleator and Crown King

John J. Ward

We had driven to Bumblebee for a picnic one scorching summer day, but we soon discovered that the hot, barren landscape was not the ideal place. Seeking the cooler air of a higher elevation, we pressed on to Cleator, then up a series of switchbacks to Crown King.

The narrow road, built on the old railroad right-of-way, cut through rocky ridges only wide enough for a single lane in many places. Fortunately we met few vehicles. Cautiously transiting a final cut through a solid rock barrier, we entered a ponderosa pine forest at the 6,000-foot level and suddenly were in the middle of the former gold-mining center of Crown King.

We parked in the town square and walked up a long disused roadway that wrapped around a ridge and continued upward to the site of several old mines which had played out and been abandoned decades earlier. We assumed there would be no water here so near to the 7,500-foot

crest of the Bradshaw Mountains, but all the old mine shafts were flooded, some waist deep. Water seeped out of recent deer and javelina tracks. Among the rusted cans in the dumps among manzanita thickets were those of another era when Log Cabin syrup came in cans shaped like log cabins. The miners had eaten a lot of pancakes. Some cans had bullet holes, and most of the glass had been broken. After lunch we tossed our modern cans among their older brethren in the ancient trash dumps.

The sun was already behind Tower Mountain when we got back to the little town square. One of the larger buildings had been the old dance hall with rooms above once occupied by busy ladies of the evening and their customers. The big dance hall had little furniture except an old cavalry stove built in sections that could be disassembled and transported by pack animals. Pictures of Crown King in its heyday hung along the otherwise bare, tongue-in-groove wooden walls. One black and white photo was of the busy railroad switching yard. Another showed a man in formal attire, including top hat, performing some official function. A nearby chart explained the signals used for the underground elevators.

To the right of the wood stove was a small room containing the town's only bar. A little graying Irishman told us the man in the tails and top hat was his father, who was then the mayor of Crown King. A woman came in the bar to ask where the

restrooms were located. "Outside. But you ain't goin' to rest for long in there," a customer quipped.

They talked of an upcoming turkey shoot and took us outside and a hundred yards uphill to a practice range with little metal turkey silhouettes strung on a taut wire. We all took turns with a 22-caliber rifle. My partner, Carol, a qualified marksman with the Arizona Air Guard, almost tied the last champion but failed by a single point. This called for more celebration in the bar with more beer in front of us than we could have consumed in a week. "I'd like to buy you a drink," the former mayor's son kept saying.

"Can't possibly drink any more," we protested. "And we've gotta get down those switchbacks before dark."

"Dark's the very best time to go down," said the Irishman. "They ain't likely to be no cars on the road, and they's no need to worry about the two-hundred-foot drop-offs that ye can't see," he laughed. "Give 'em another beer, Dave."

The mayor's son told us that the switchback railroad had been built by laborers brought in from the East Coast and paid enormous wages in that era of a dollar a day. Some got gold fever and left for the mines, but it was easy to induce others to come West. He said millions in gold-bearing ore were taken down the switchbacks. At first, gold brought $12 then later increased to $18 per ounce, he said.

When, despite spirited protests by the bar patrons, we finally emerged, the night was pitch black. At the general store we inquired if there might be a cabin for rent. The proprietor cranked a wall telephone and talked to someone. While we waited I asked about Walt, their contract mail carrier whom I'd known years before. I'd heard he left the civil service because of a drinking problem.

"He's still carrying the mail. Hung around longer than usual today."

"Is he still drinking?" I asked.

"He was popping them little white onions. Thinks that covers up his alcohol breath. Actually makes it worse—an alcohol and onion breath."

A few minutes later a man entered through the squeaking front door. "You the folks who need a place to stay?" When we nodded he went on. "That's it over there," he pointed to a dim outline across the square. "It's twenty dollars," he grinned. "Go on over when you're ready. Ain't locked."

The place was not a cabin but a spacious cottage. We slept soundly in the chilly, 6,000-foot mountain air. Famished the next morning, we went to the Tie House, Crown King's only restaurant, for a huge breakfast. After the unplanned big Saturday night in Crown King, we were mortified to find we were short by 95 cents of having enough to pay our breakfast

check. The pretty proprietor said, "Oh, that's all right. Pay me the next time you're up. You may need something to get home on."

On our way home we stopped at the little bar in Cleator. The proprietor, Tommy Cleator, was the son of the town's founder. A huge man, with a great white beard and an immense stomach, he sat behind the tiny bar armed with a flyswatter. Since everything was within reach, he seldom found it necessary to leave his big chair. Cleator told us the route we'd hiked the previous day was called Lincoln Road.

In the back of the dim room was an old nickelodeon that still played 78-rpm records, five cents each play or six for a quarter. A wizened old man entered and sat at a tiny table by the wall. His little dog trotted behind him and lay contentedly near the old man's feet.

"Can your dog do any tricks?" Carol asked the old-timer.

"Sick! Course he ain't sick. He's jest tired. Been herding sheep all day."

Carol took several pictures of the old timer and his faithful dog, got his address, and promised to mail him copies.

It was in October more than a year later when we managed to revisit Crown King, looking forward to returning to the Tie House and finally settling up for our unpaid breakfast check. The pretty lady was gone and the new owners had no

idea who nor where she was. The rustic Tie House restaurant had been expanded and a bar added. The old dance hall bar across the square also had new owners who retaliated by opening a restaurant.

This time we climbed to the top of Tower Mountain, highest point in the Bradshaws. The fire season was over and the firetower was unmanned. But the mountain had other visitors— billions of ladybugs, thick enough to scoop up with shovels. In autumn ladybugs congregate on the highest terrain of an area in a spectacular ladybug convention or reunion. Entomologists believe these gatherings are purely social.

The bar at Cleator was closed when we came down off the switchbacks and was never open again on any of our subsequent trips. Walt was still delivering the mail, nipping from a bottle in a paper bag along the route and popping onions when he thought it necessary. He must have delivered pictures of the little "tired" dog to the old sheepherder. At least the envelope never came back.

❁

Canyon West Of Sierra Vista

Dorothy Lykes

At the turn of the century,
miners sat around campfires
singing words they learned at home
in Cornwall. They danced
through the cool evenings feasting
on clean air before climbing aboard
wagons and whipping horses back
to Bisbee where they spent their lives
mining copper ore inside the hills.

Hoping to replace the canyon's brown
desert grasses with England's
everlasting green, these miners
planted periwinkle
under giant oak trees
where hummingbird nests
of cobweb and lichen
were secured to branches.

Trogon parrots from Mexico
flashed through sycamores in spring.

A hundred years later
a vigorous blanket of periwinkle,
spreading green tendrils
with tiny purple blooms, permeates
the shaded canyon.

Men, desiring to see dirt again,
to give earth to sun,
so leaves can drop
orange carpets on the ground,
acorns reseed oaks, and golden grasses
stirred by monsoon winds
breathe soft songs into the air,
fight the periwinkle.

Mowing does not kill.
Brown scars show evidence
of burning the periwinkle.
Bagged green stretches remain
where scientists spray chemicals, and
tenacious vines run further into forests.
In this dragged-out war
the English plant remains victorious.

The Golden State Unlimited: The Douglas Cat Migration

Clara Belle Schlotzhauer

The westbound Golden State Limited arrived in Douglas, Arizona promptly, more or less, at 2:30 p.m. It was a beautiful train with a big steam engine, an American Express car, a baggage car stacked with trunks, two-to-four chair cars, a parlor car, a diner, two sleepers, and occasionally a private car.

Every day about 2 o'clock, from all over town and the outskirts, cats headed for the train depot. Most of them came from nearby Pirtleville and Boneyville, but many came from the slightly better sections of Douglas.

The cats, of all sizes and colors and varieties, collected along the north side of the tracks, the side away from the depot. They waited—quietly and politely—for the train, strategically hunkered down at exactly the spot where the diner would roll to a stop.

As soon as the Limited pulled in, the cats—tails swishing in anticipation and ears flicking—watched alertly, waiting patiently as close to the noisy train as they dared. Then, from the train's diner windows and from the narrow observation platforms between the cars flanking the diner, cooks and waiters and Red Caps, and even some of the passengers, tossed food scraps to the furry mass of suddenly animated cats.

These were not just eight or ten starvelings. These cats added up to a delegation of two-to-three hundred very well-fed cats!

This Douglas phenomenon made Robert Ripley's "Believe It Or Not" newspaper cartoon. Believe it!

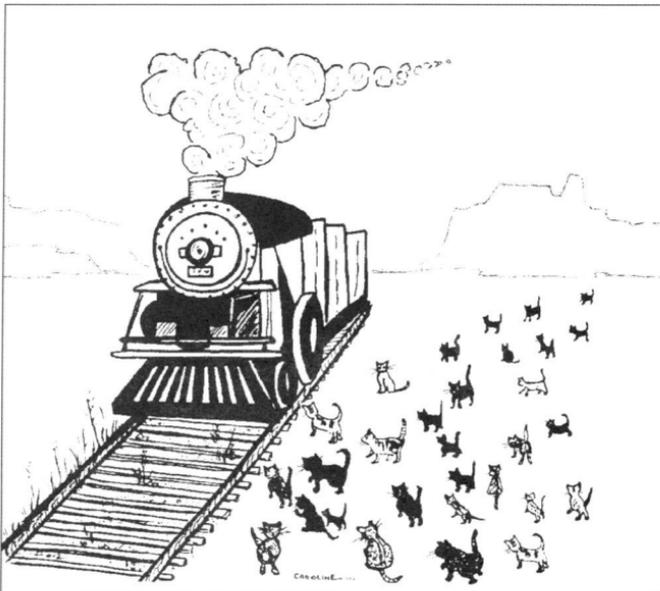

The Road to Shadow Valley

Frances Libby

I memorize the turns
to learn the journey
alone in January snow
hunting a feeble glow
in wide Shadow Valley.

This road from Whiskey Row
is no crow flight
but erratic as a miner's track
straying home
after a Saturday night

erasing with rotgut
memory of the week's black pit.
His ghost shambles at my side
rusty-lunged, rheumy-eyed.

We move among a band
of nameless shapes
who offered up their breath
to make this place a town.
They crowd around me
on this empty, peopled road.

Spindrift

Jules Klagge

Rich, red clay
 baked into a sturdy pot
 determined by the potter's hands.

Designs in black
 painted on its surface
 relate a tale
 of gods and tumble weeds,
 of coyotes and men
 bound together
 by a web of circumstance.

Its bottom broken
 to allow the spirit
 freedom from the cage
 of stern utility,
 it lies abandoned
 by the maker
 and those whom it served well.

A tide of desert sand
 driven by the surge
 of arid winds
 provides a ground
 for burial
 of broken pots
 and men.

Phyllis Whitecloud's Bowl

Dorothy Lykes

My hands enclose
the terra-cotta
Indian bowl
glazed in colors
of iron ore
cotton bolls
and thick streamers
from low rain clouds.

A Papago woman
once eased this pot
from wet clay.
She fired it in a beehive kiln
using mesquite
from the parched desert.

Around the rim
stick-warriors
shuffle moccasins
 circling.

As I hold the bowl
between my palms
I feel a pulse.

CAROLINE ...

About the Authors

John L. Ames was born in Freedom, Wyoming in 1907. As teacher or administrator, he served in the public schools of Wyoming, Minnesota, Utah, California and New York. He is a professor emeritus from Queens College, City University of New York. Dr. Ames has published two books of poetry and his work has appeared in several anthologies.

John R. Anderson, a native Arizonan, is a retired cattle rancher still active in cattle feeding. As a board member of the eleventh district of the Farm Credit Board, he wrote letters, reports, and speeches. He is now collaborating with his wife in writing the biography of his father, a ranching pioneer of Arizona's Territorial days.

Alda N. Becker is an Ohio native who has been involved in Girl Scouting for more than 55 years. She has taken hundreds of camping trips all over the United states, back-packing hikes in the Olympic Mountains of Washington, raft trips down the Colorado River, and a mule trip to the bottom of the Grand Canyon. Other interests include, travel, photography and writing.

Beatrice Bradshaw was born in upper New York State early in this century. Recently widowed, she was married sixty-five years to a Congregational minister. Her chief hobbies include writing memoirs and letters to her many descendants.

Nell Brown was brought to Arizona shortly after her birth in the Texas Panhandle. Her childhood experiences on a homestead in western Arizona and in a one-room school have given her a unique perspective on Arizona's past. She is a retired civilian employee of the United States Air Force. Her hobbies include writing, photography, and lifelong learning.

Lewis R. Burch was born in Phoenix in 1921, the son of a Phoenix policeman killed in the line of duty. He served with the U.S. Navy in the South Pacific during World War II, later becoming a teacher. He also served two terms in the Arizona legislature. His stories have been published in local journals. Mr. Burch's gardening efforts have won him many ribbons at the Arizona State Fair.

Caroline Haines Burke, born in New Jersey, has lived in Arizona since 1947. An avid reader and doll collector, Caroline also raises several species of turtles in her backyard gardens. Her work—fiction, non-fiction, and artwork—has appeared in several local and national publications.

Magdalene Barber Fennell is a retired school principal and writer of essays, short stories, and op ed news articles. She and her husband provide support and counsel to thirty-one middle school students, each of whom will receive an equal share of an investment fund established to provide educational scholarships for them.

Robert W. Finkbine taught history at Arcadia and Coronado High School for twenty-nine years. Currently he is a whitewater river guide. Most of his poetry is inspired by his experiences in the wilderness, backpacking and running wild rivers. He has completed a book of poems, *Smoke that Roars*, about the Grand Canyon.

William B. Grove was born in California, but has lived in Phoenix for more than 60 years. A former auditor and procedure writer for Arizona Public Service Co., Mr. Grove enjoys writing juvenile prose and poetry. His work has appeared in *Joyful Child Journal* and *Poem Train*.

Lois Harbert is a native Iowan whose work has been published in Doll Collector magazines and in the *Friend*, a children's religious magazine. She was the recipient of an award in the biennial writer's contest sponsored by *Guideposts* magazine. Her prose has appeared in other anthologies published by the Senior Adult Writing Project.

Helen Krikorian Jones is a semi-retired teacher who has worked in the public schools of New Jersey, Massachusetts, California, and Hawaii. Her poems have appeared in *Ararat, Rainbird,* and *A Festival of Poetry.* She is an accomplished calligrapher.

Jules M. Klagge is a retired attorney and army colonel who has been an Arizona resident since 1922. He has taught courses at Arizona State University, and has served in federal, state, and city governments. He is a member of the Arizona Masterworks Chorale, and is an active volunteer at Desert Botanical Garden.

C. James Krafft is a native of Eliasville, Texas (population almost 100). He has practiced medicine for 46 years. A hiker and an active member of the wellness movement, Dr. Krafft has been writing poetry for ten years. He is co-founder of Friends of Walnut Canyon, a conservation group.

Helen Rul Lawler is a former high school teacher who married into a pioneer Prescott family. Her published writing includes brochures for cooking classes, haiku, and true stories of characters who worked for her husband's family in Arizona Territorial days.

Frances Libby, a Texas native, did magazine and newspaper work before studying art at ASU. She taught art in the Scottsdale area for many years before her career as a poet. Her poetry has been published in *Sandcutter, Fennelstalk, Avalon Dispatch,* and *A Long Road Winding.*

Dorothy Raitt Lykes is a widely published poet and teacher of poetry. A native of California, she has actively promoted creative writing in the Valley for many years. Many of her students at the Scottsdale Senior Center have themselves become accomplished writers. She is a former president of the Arizona State Poetry Society.

Sandra W. McFate is a registered Professional Reporter whose articles have been published in *The National Shorthand Reporter, The Journal of Court Reporting, Maricopa Lawyer,* and *LeCourt Magazine.* Recently retired, she devotes her time to travel, photography, and writing. Two of her plays, *Just a Smidgen*, and *Perfect Hearing*, were produced by the Scottsdale Senior Center.

Violet Miller is an Ohio native who has spent the last thirty years in Arizona. A member of Arizona Poetry Society and Phoenix Writers' Club, she recently completed a second novel and is working on a third. Her writing has won many contest awards, and her poems have been published in *Sandcutters*.

Jeanne S. Resnick is emeritus associate professor of English at State University of New York at Morristown. She lives in Scottsdale, where she takes creative writing classes. In addition to writing poetry and screenplays, her interests include golf, bridge, swimming, and sailing.

Lillian Risner came to Arizona from Texas in 1917. Her father was one of the first settlers to break the land in what is now south Phoenix. Her stories of early Phoenix and the Salt River Valley make captivating reading. A retired teacher, she currently makes her home in Sierra Vista.

Clara Belle Schlotzhauer was born in Douglas, Arizona territory, three years before statehood. Growing up in a border town was exciting during that era of raids and revolutions. After living in Washington D.C. and the Bay Area of California, she is happy to spend her retirement years in Phoenix.

John E. Schwartz, a Pennsylvania native, worked as a commercial writer before coming to Arizona in 1972. He has continued freelance writing during two Arizona careers, first as an insurance agent and later as an auctioneer in the Prescott area. Though "Warm Feelings on a Cold Night" is a fiction piece, it is authentically set in Arizona's territorial capitol at the turn of the century.

Charles Still is a retired physician who grew up in Kirksville, Missouri, where his grandfather, A.T. Still, founded osteopathy. He recently published a biography of his famous grandfather, *Frontier Doctor, Medical Pioneer*. Dr. Still served as the first chairman of the Governor's Council on Aging, and remains keenly interested in issues concerning aging.

John J. Ward is a native of West Virgina whose writings have appeared in many local and national publications, including *Reader's Digest, Catholic Digest, Organic Gardening, Sky, Arizona Highways*, and many others. A former radio officer on merchant ships, he was an Air Traffic Control specialist with the Federal Aviation Administration for 27 years.

Pat Wasielewski is a Phoenix native who has lived in several other Arizona communities. A member of the First Families of Arizona, Mrs. Wasielewski is interested in the history of Arizona and intends to draw from this rich heritage for future stories. She studies writing at the community college and at the senior center.

Don West is a retired mining engineer from Hamilton, Ontario. He served with the Royal Canadian Air Force in World War II, and later with NATO forces in France. Emigrating to the U.S. in 1963, he worked as an aerospace engineer and mining engineer until his retirement. He began writing only three years ago, but his short stories have already won significant recognition.

Order Form

Senior Adult Writing Project
Scottsdale Community College
9000 E. Chaparral Road
Scottsdale, AZ 85250

Please ship _____copies of *Brittlebush* @ *8.95
postpaid.*
Check or money order enclosed.

(Please Print)

NAME_____

ADDRESS_____

CITY_____STATE_____ZIP CODE_____

Order Form

Senior Adult Writing Project
Scottsdale Community College
9000 E. Chaparral Road
Scottsdale, AZ 85250

Please ship _____copies of *Brittlebush* @ *8.95
postpaid.*
Check or money order enclosed.

(Please Print)

NAME_____

ADDRESS_____

CITY_____STATE_____ZIP CODE_____